THE LIFE OF CHRIST

Presented to

Eleanor J. Immler

in recognition of her

7 years dedicated service

to the music program of

Holy Nativity Lutheran Church

THE LIFE OF CHRIST

IMAGES FROM THE METROPOLITAN MUSEUM OF ART

Compiled by Barbara Burn

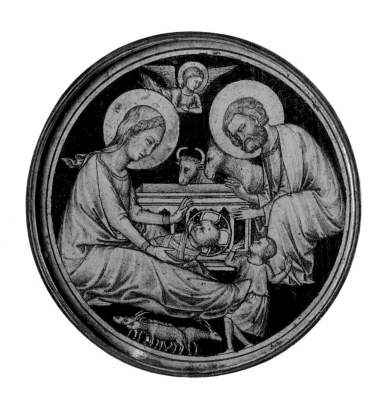

THE METROPOLITAN MUSEUM OF ART

New York

CHARLES SCRIBNER'S SONS

New York

Foreword

The life of Jesus Christ has provided an inexhaustible font of inspiration
for visual artists. The history of European art is rich in images depicting the
figure of the Saviour and the events in his life as set forth by the four
Evangelists, Matthew, Mark, Luke, and John. It is a tribute to The Metropolitan
Museum of Art that virtually every important episode in Christ's life can be
illustrated with a work of art drawn from its vast collections. We hope that
this handsome volume will serve to enrich our appreciation of the aesthetic as
well as the spiritual nature of the Gospels.

Philippe de Montebello
Director
The Metropolitan Museum of Art

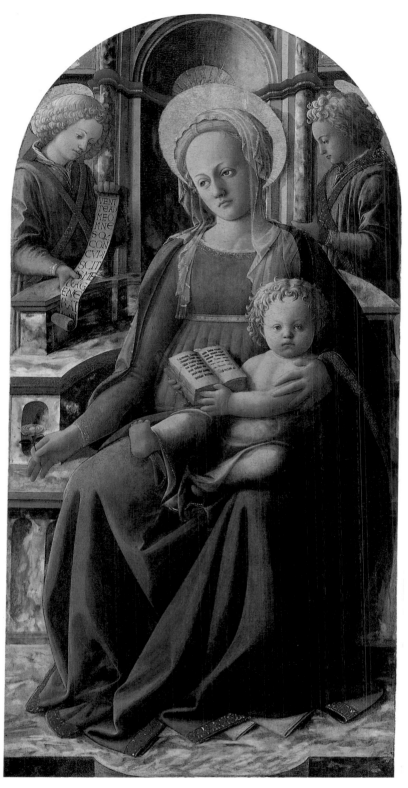

MADONNA AND CHILD
ENTHRONED, WITH TWO ANGELS
Fra Filippo Lippi

I N the beginning was the Word, and the Word was with God,
and the Word was God.

JOHN 1: 1

THE ANNUNCIATION
Botticelli

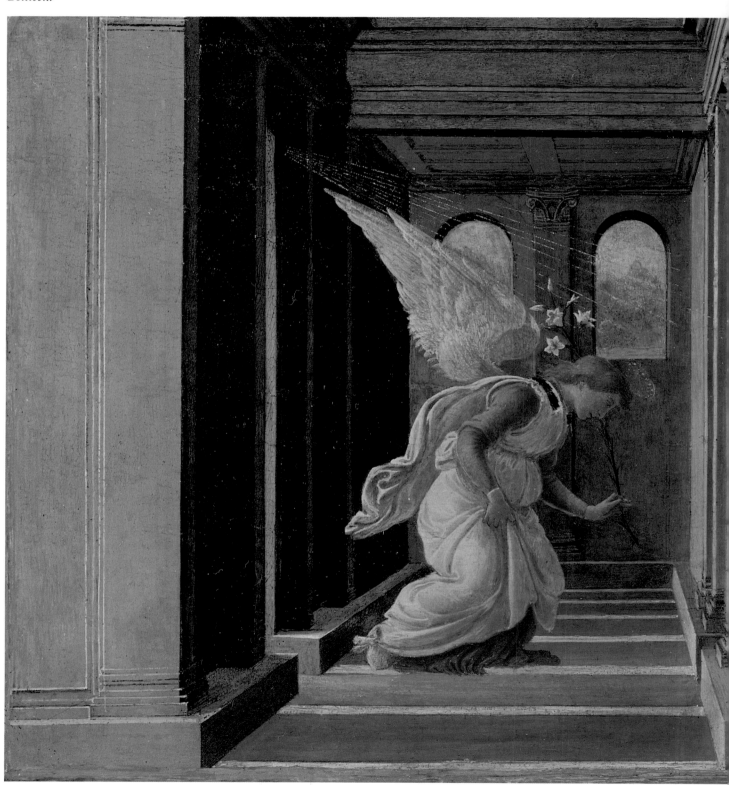

AND the angel said unto her, Fear not, Mary: for thou hast found favour with God. And, behold, thou shalt conceive in thy womb, and bring forth a son, and shalt call his name JESUS. He shall be great, and shall be called the Son of the Highest: and the Lord God shall give unto him the throne of his father David: And he shall reign over the house of Jacob for ever; and of his kingdom there shall be no end.

LUKE 1: 30–33

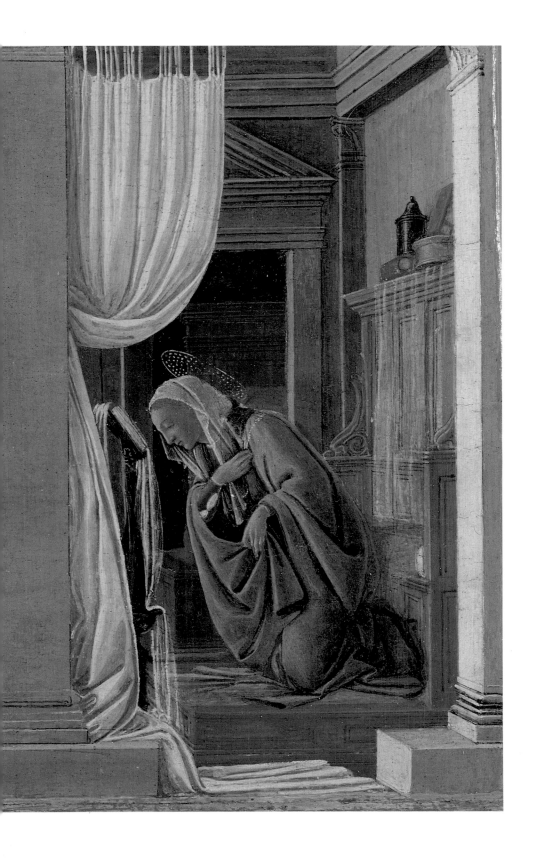

THE VISITATION
Attributed to Master Heinrich of Constance

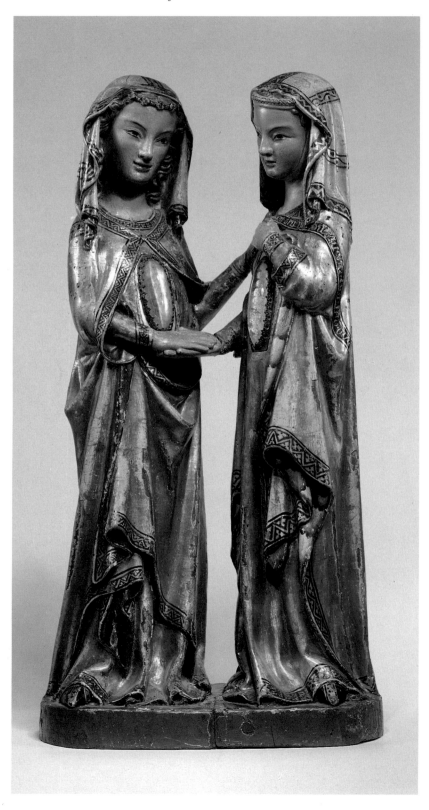

AND Mary arose in those days, and went into the hill country with haste, into a city of Juda; And entered into the house of Zacharias, and saluted Elisabeth. And it came to pass, that, when Elisabeth heard the salutation of Mary, the babe leaped in her womb; and Elisabeth was filled with the Holy Ghost: And she spake out with a loud voice, and said, Blessed *art* thou among women, and blessed *is* the fruit of thy womb.

LUKE 1: 39–42

THE BIRTH OF SAINT JOHN THE BAPTIST
Francesco Granacci

Now Elisabeth's full time came that she should be delivered; and she brought forth a son. And her neighbours and her cousins heard how the Lord had shewed great mercy upon her; and they rejoiced with her.

LUKE 1: 57–58

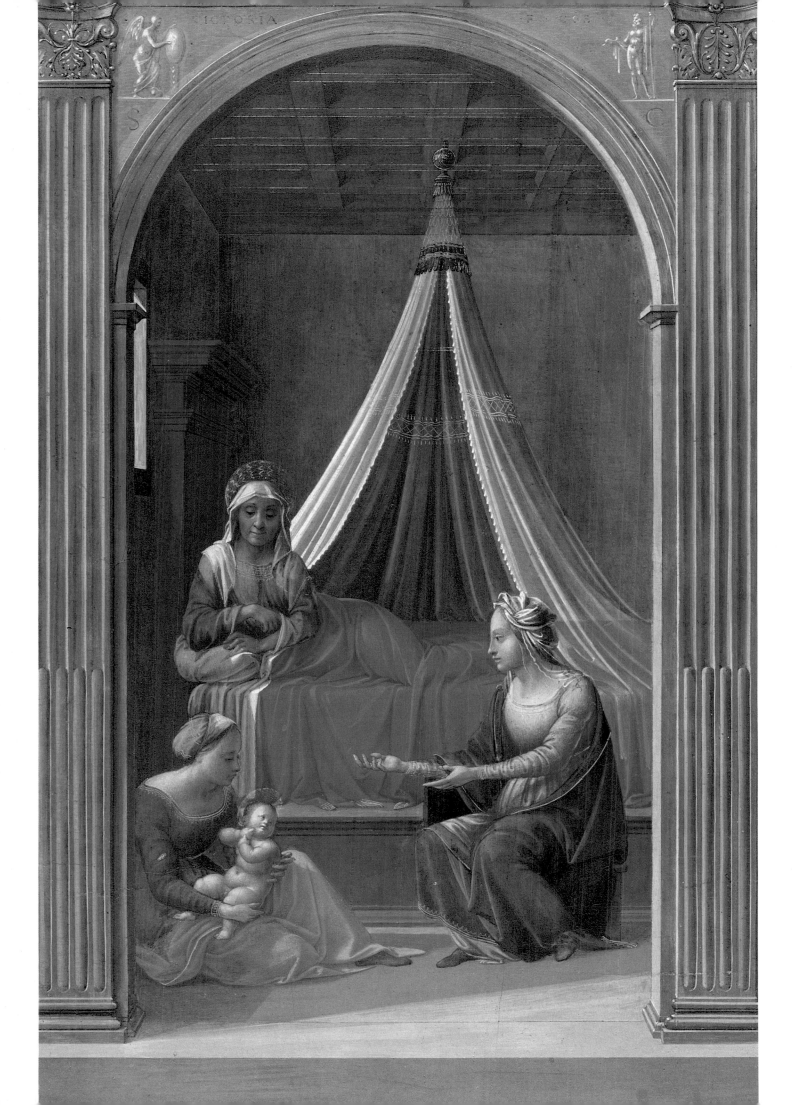

And it came to pass in those days, that there went out a decree from Caesar Augustus, that all the world should be taxed.... And all went to be taxed, every one into his own city. And Joseph also went up from Galilee, out of the city of Nazareth, into Judaea, unto the city of David, which is called Bethlehem, (because he was of the house and lineage of David:) To be taxed with Mary his espoused wife, being great with child.

<div align="right">

LUKE 2: 1, 3–5

</div>

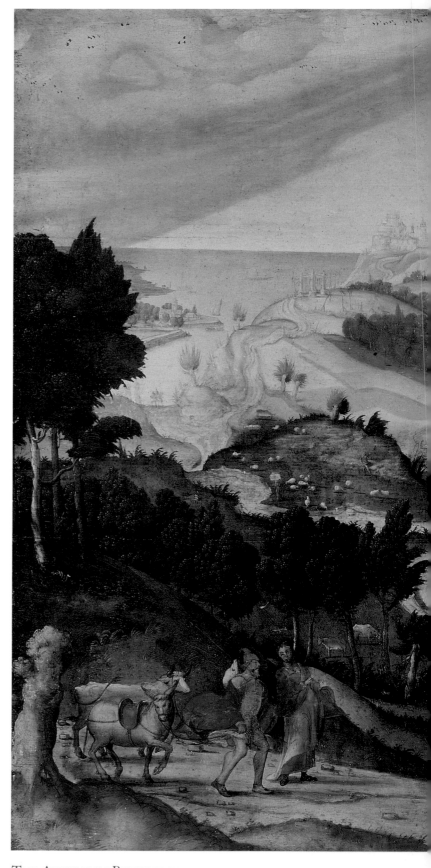

THE ARRIVAL IN BETHLEHEM
Master LC

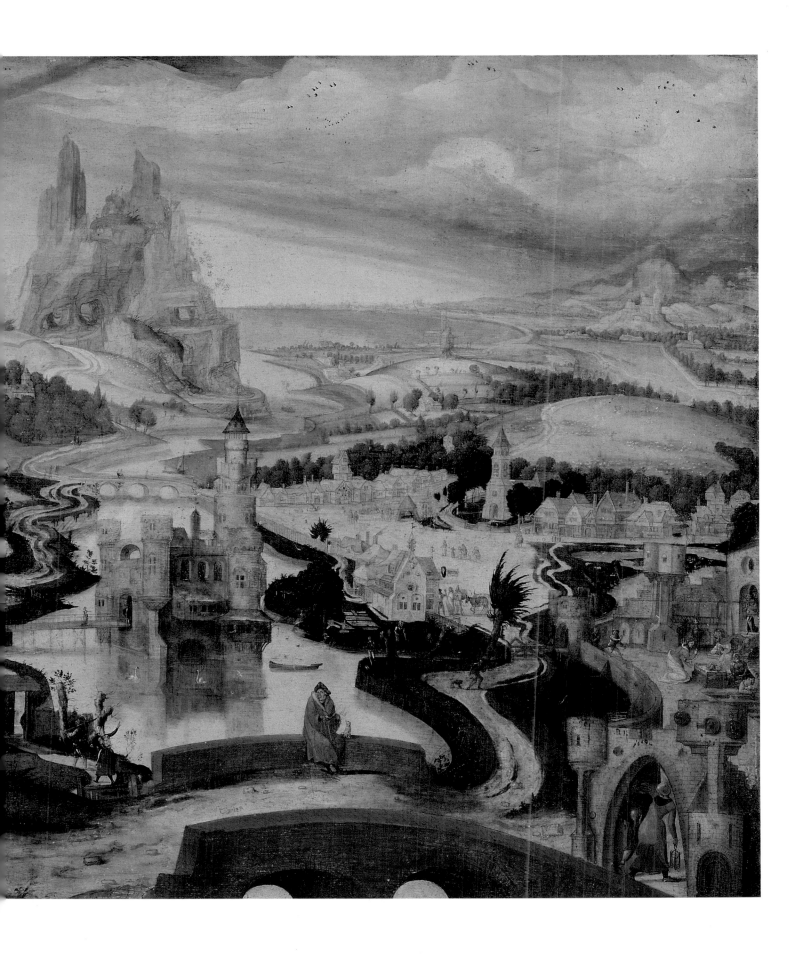

And so it was, that, while they were there, the days were accomplished that she should be delivered. And she brought forth her firstborn son, and wrapped him in swaddling clothes, and laid him in a manger; because there was no room for them in the inn.

LUKE 2: 6–7

And there were in the same country shepherds abiding in the field, keeping watch over their flock by night. And, lo, the angel of the Lord came upon them, and the glory of the Lord shone round about them: and they were sore afraid. And the angel said unto them, Fear not: for, behold, I bring you good tidings of great joy, which shall be to all people. For unto you is born this day in the city of David a Saviour, which is Christ the Lord. And this *shall be* a sign unto you; Ye shall find the babe wrapped in swaddling clothes, lying in a manger. And suddenly there was with the angel a multitude of the heavenly host praising God, and saying, Glory to God in the highest, and on earth peace, good will toward men.

LUKE 2: 8–14

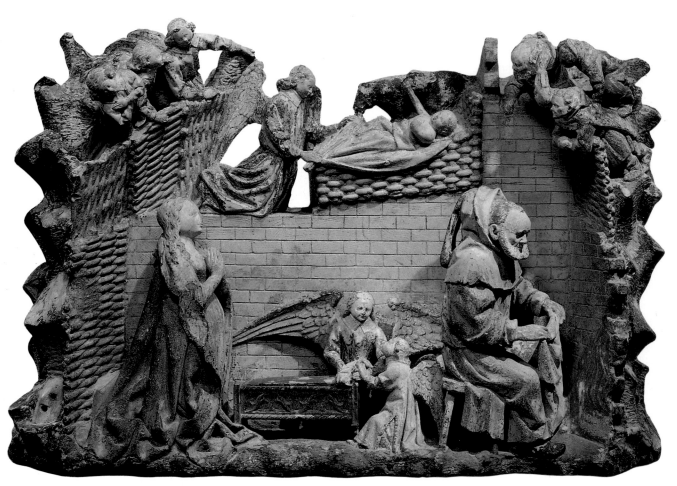

THE NATIVITY
Unknown French sculptor

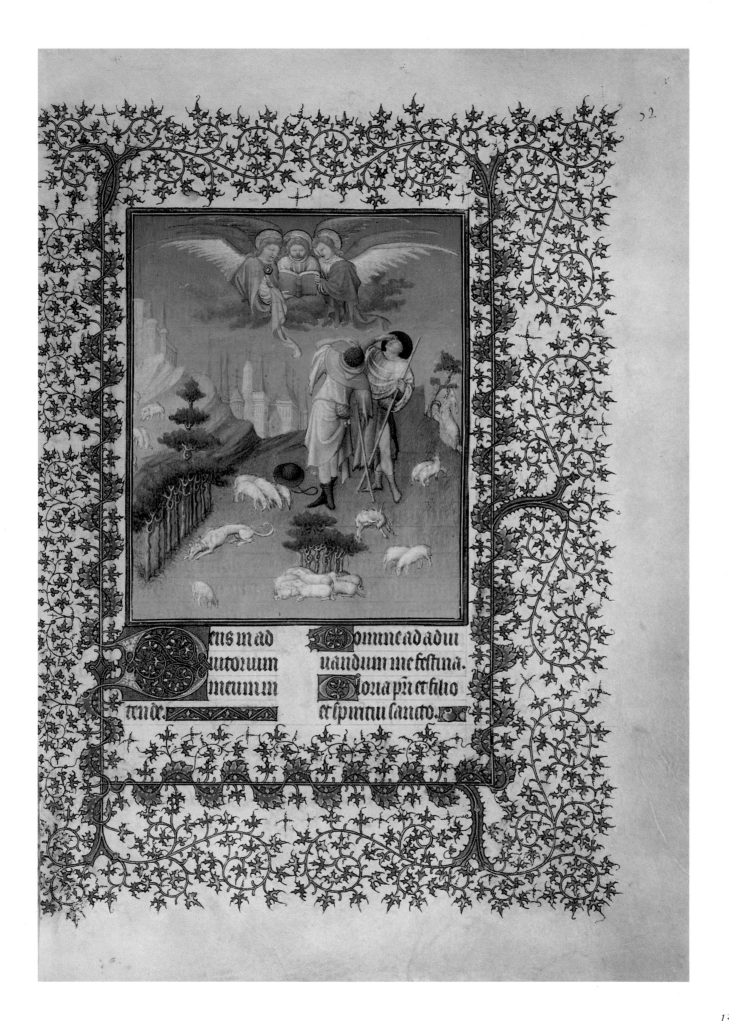

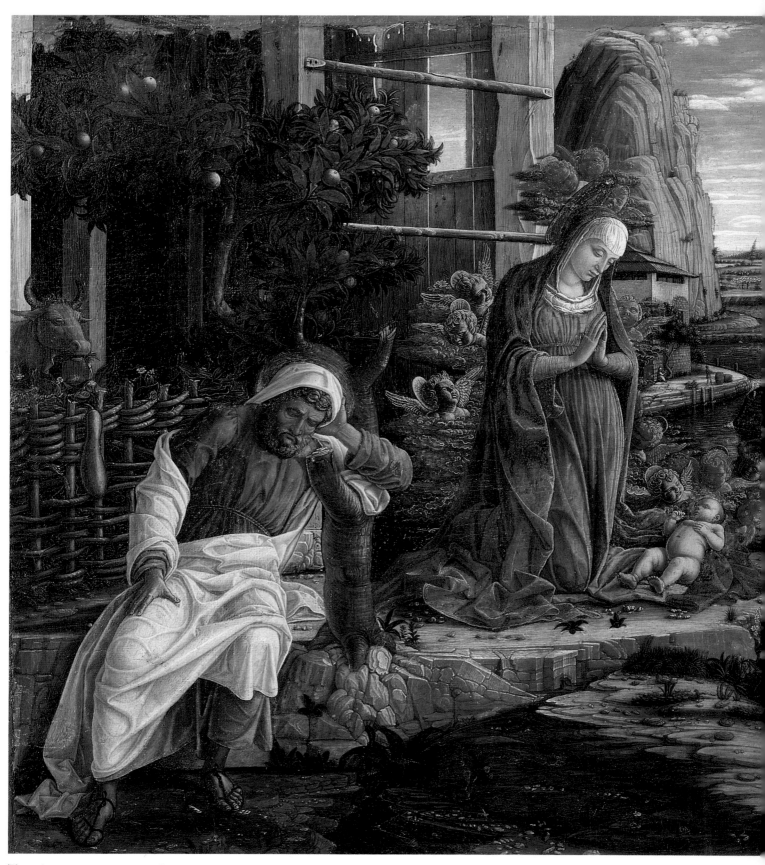

THE ADORATION OF THE SHEPHERDS
Andrea Mantegna

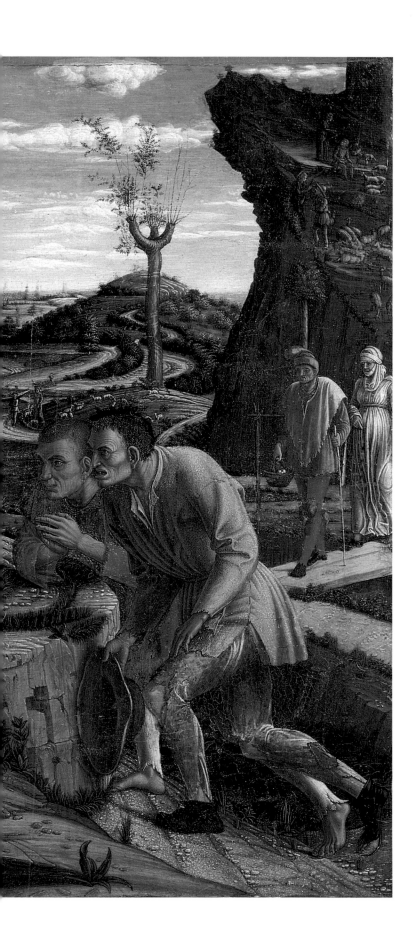

AND it came to pass, as the angels
were gone away from them into
heaven, the shepherds said one to
another, Let us now go even unto Bethlehem,
and see this thing which is come to pass,
which the Lord hath made known unto us.
And they came with haste, and found Mary,
and Joseph, and the babe lying in a manger.

LUKE 2: 15–16

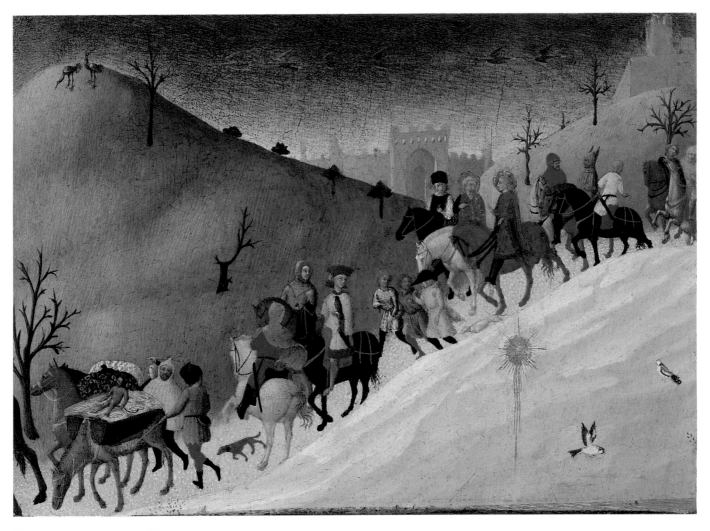

THE JOURNEY OF THE MAGI
Sassetta

Now when Jesus was born in Bethlehem of Judaea in the days of Herod the king, behold, there came wise men from the east to Jerusalem, Saying, Where is he that is born King of the Jews? for we have seen his star in the east, and are come to worship him.

MATTHEW 2: 1–2

THE ADORATION OF THE MAGI
Bartolo di Fredi

And when they were come into the house, they saw the young child with Mary his mother, and fell down, and worshipped him: and when they had opened their treasures, they presented unto him gifts; gold, and frankincense, and myrrh.

MATTHEW 2: 11

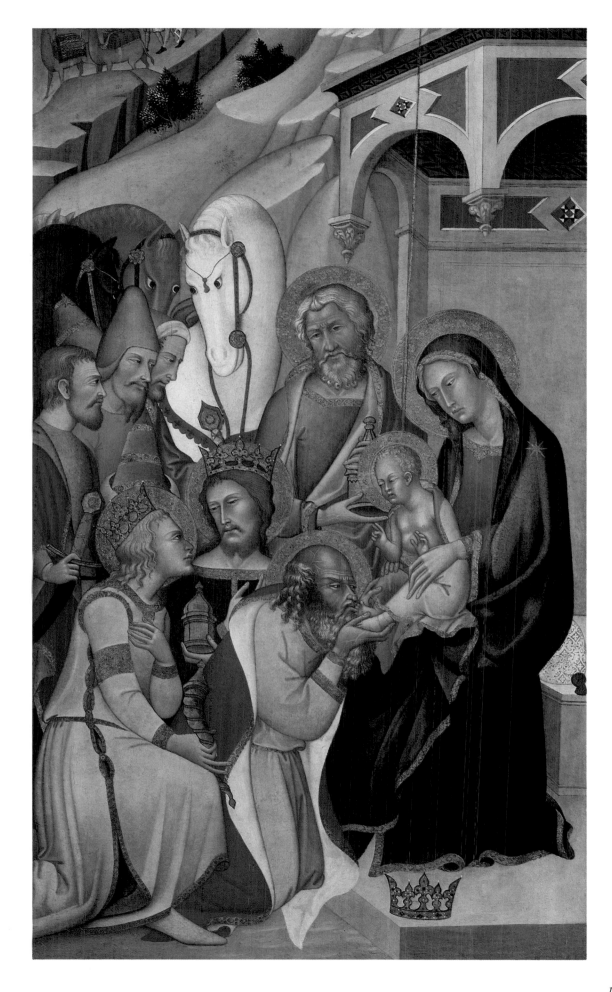

AND when eight days were accomplished for the circumcising of the child, his name was called JESUS, which was so named of the angel before he was conceived in the womb.

<div style="text-align: right">LUKE 2: 21</div>

THE CIRCUMCISION OF CHRIST
Giovanni Battista Trotti

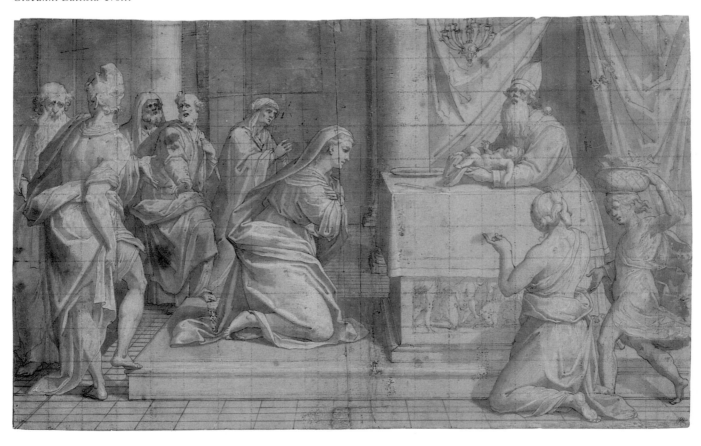

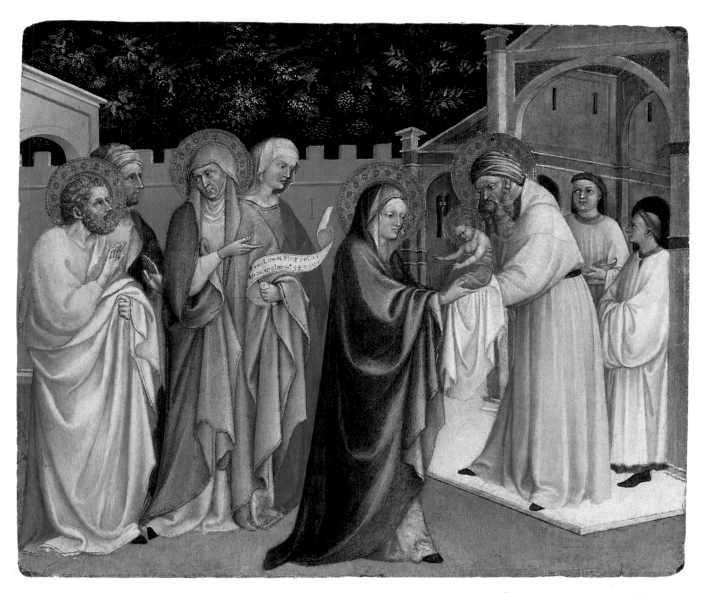

PRESENTATION IN THE TEMPLE
Unknown Italian painter

A ND when the days of her purification according to the law of Moses
were accomplished, they brought him to Jerusalem, to present *him* to
the Lord; . . . And, behold, there was a man in Jerusalem, whose
name *was* Simeon; and the same man *was* just and devout, waiting for the
consolation of Israel: and the Holy Ghost was upon him. And it was revealed
unto him by the Holy Ghost, that he should not see death, before he had seen
the Lord's Christ. And he came by the Spirit into the temple: and when the
parents brought in the child Jesus, to do for him after the custom of the law,
Then took he him up in his arms, and blessed God, and said, Lord, now lettest
thou thy servant depart in peace, according to thy word: For mine eyes have
seen thy salvation, Which thou has prepared before the face of all people;
A light to lighten the Gentiles, and the glory of thy people Israel.

LUKE 2: 22, 25–32

19

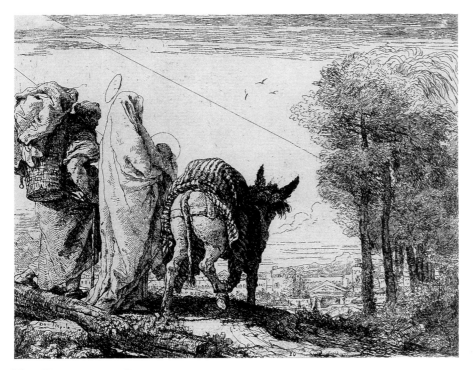

THE FLIGHT INTO EGYPT
Giovanni Domenico Tiepolo

AND when they were departed, behold, the angel of the Lord appeareth to Joseph in a dream, saying, Arise, and take the young child and his mother, and flee into Egypt, and be thou there until I bring thee word: for Herod will seek the young child to destroy him. When he arose, he took the young child and his mother by night, and departed into Egypt.

MATTHEW 2: 13–14

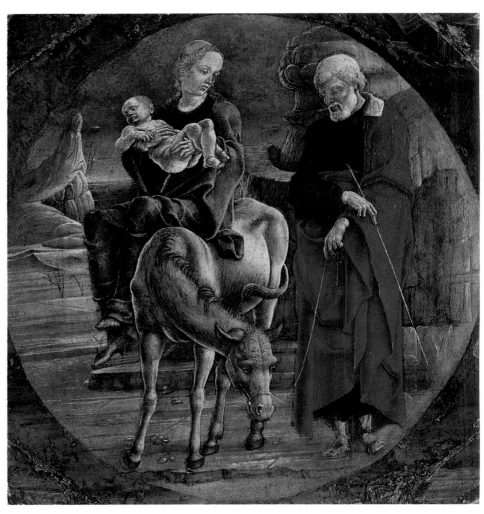

THE FLIGHT INTO EGYPT
Cosimo Tura

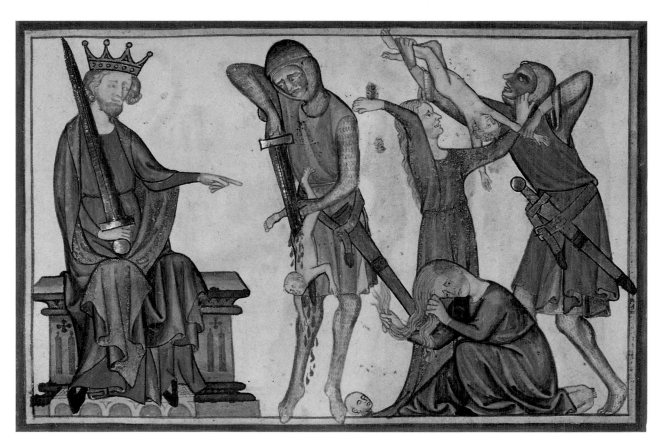

SLAUGHTER OF THE INNOCENTS
Unknown French painter

T HEN Herod, when he saw that he was mocked of the wise men, was exceeding wroth, and sent forth, and slew all the children that were in Bethlehem, and in all the coasts thereof, from two years old and under, according to the time which he had diligently inquired of the wise men.

MATTHEW 2: 16

21

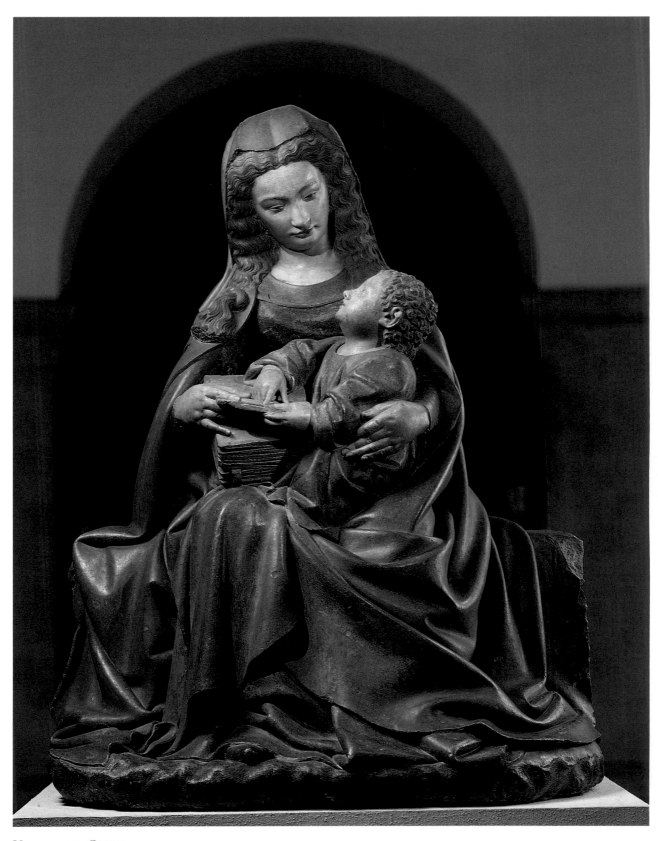

VIRGIN AND CHILD
Claus de Werve

A ND the child grew, and waxed strong in spirit,
filled with wisdom: and the grace of God was upon him.

LUKE 2: 40

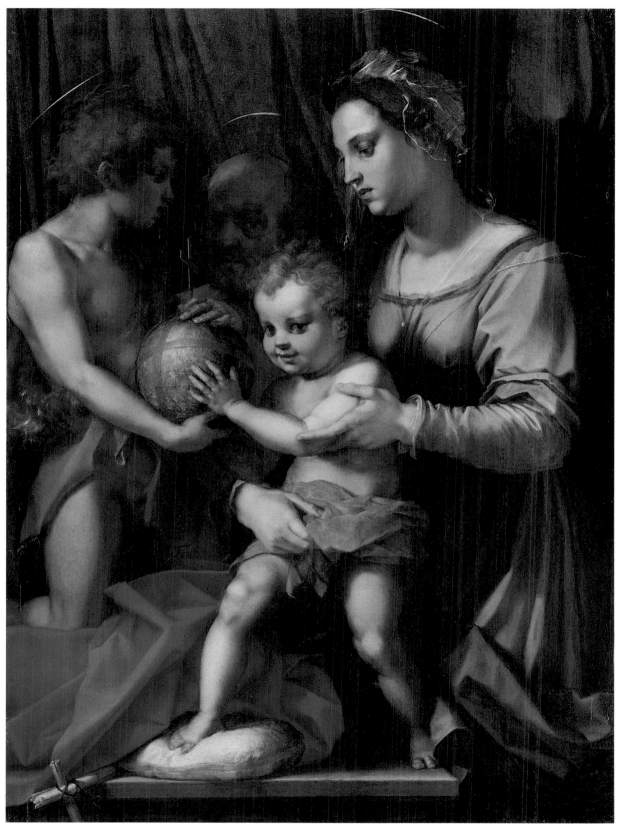

THE HOLY FAMILY WITH THE INFANT SAINT JOHN
Andrea del Sarto

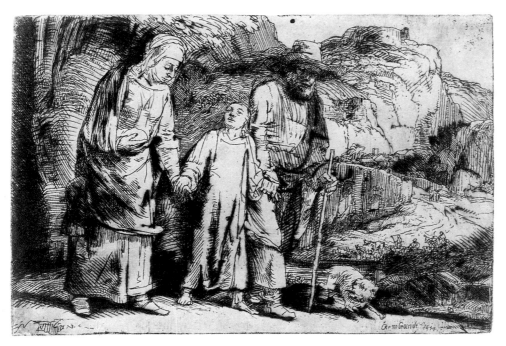

CHRIST BETWEEN HIS PARENTS,
RETURNING FROM THE TEMPLE
Rembrandt

Now his parents went to Jerusalem every year at the feast of the passover. And when he was twelve years old, they went up to Jerusalem after the custom of the feast. And when they had fulfilled the days, as they returned, the child Jesus tarried behind in Jerusalem; and Joseph and his mother knew not *of it*. But they, supposing him to have been in the company, went a day's journey; and they sought him among *their* kinsfolk and acquaintance. And when they found him not, they turned back again to Jerusalem, seeking him. And it came to pass, that after three days they found him in the temple, sitting in the midst of the doctors, both hearing them, and asking them questions. And all that heard him were astonished at his understanding and answers. And when they saw him, they were amazed: and his mother said unto him, Son, why hast thou thus dealt with us? behold, thy father and I have sought thee sorrowing. And he said unto them, How is it that ye sought me? wist ye not that I must be about my Father's business? And they understood not the saying which he spake unto them.

LUKE 2: 41–50

CHRIST AMONG THE DOCTORS
Unknown German sculptor

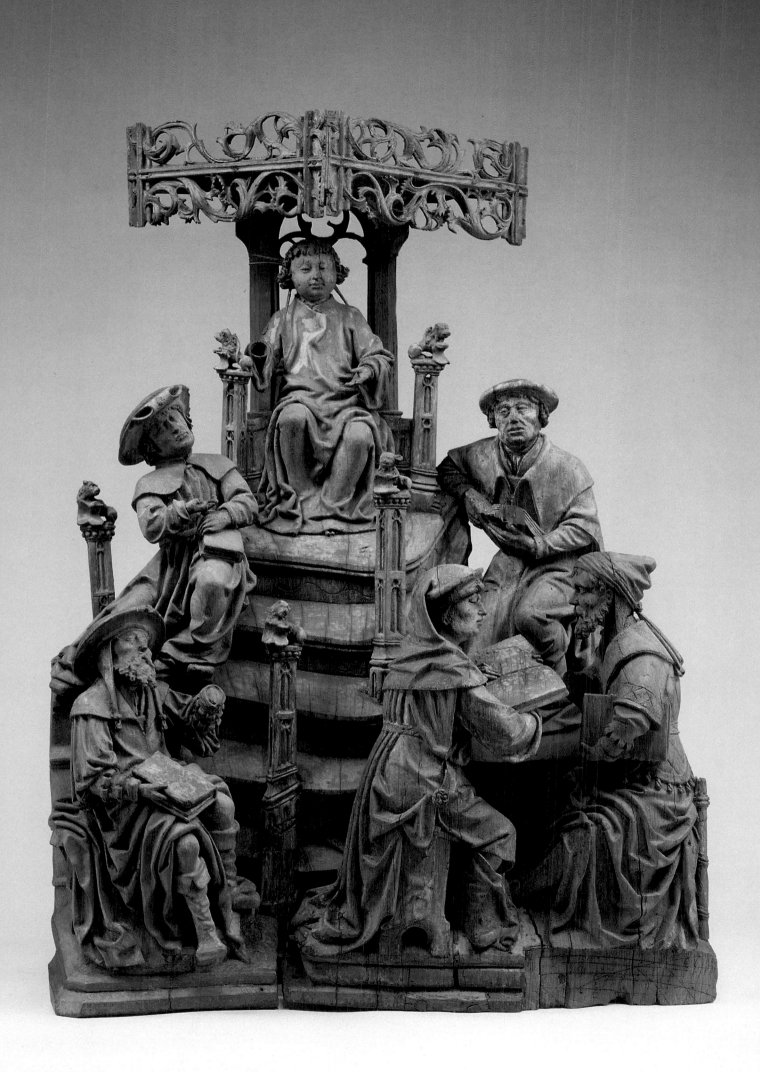

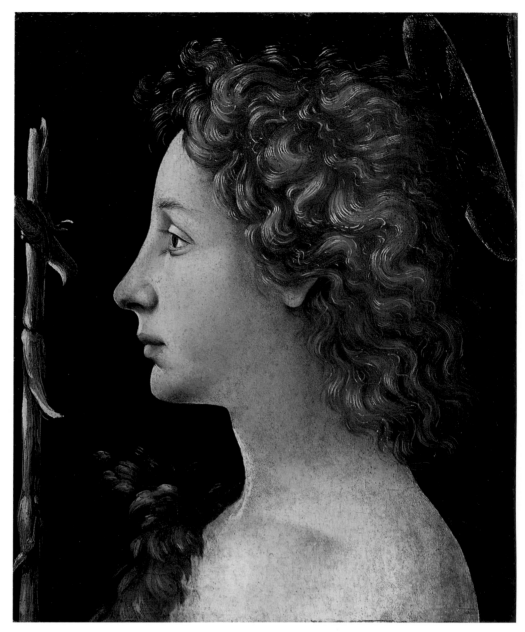

THE YOUNG SAINT JOHN THE BAPTIST
Piero di Cosimo

JOHN did baptize in the wilderness, and preach the baptism of repentance for
the remission of sins. And there went out unto him all the land of Judaea, and
they of Jerusalem, and were all baptized of him in the river of Jordan,
confessing their sins. And John was clothed with camel's hair, and with a girdle of
a skin about his loins; and he did eat locusts and wild honey; And preached, saying,
There cometh one mightier than I after me, the latchet of whose shoes I am not
worthy to stoop down and unloose. I indeed have baptized you with water: but he
shall baptize you with the Holy Ghost.

MARK 1: 4–8

THE BAPTISM OF CHRIST
Joachim Patinir

ND it came to pass in those days, that
Jesus came from Nazareth of Galilee,
and was baptized of John in Jordan.
And straightway coming up out of the water,
he saw the heavens opened, and the Spirit like
a dove descending upon him: And there came
a voice from heaven, *saying*, Thou art my
beloved Son, in whom I am well pleased.

MARK 1: 9–11

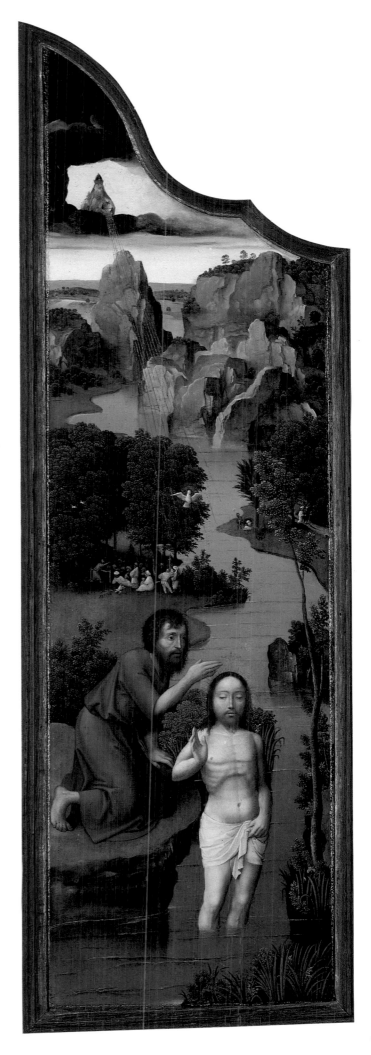

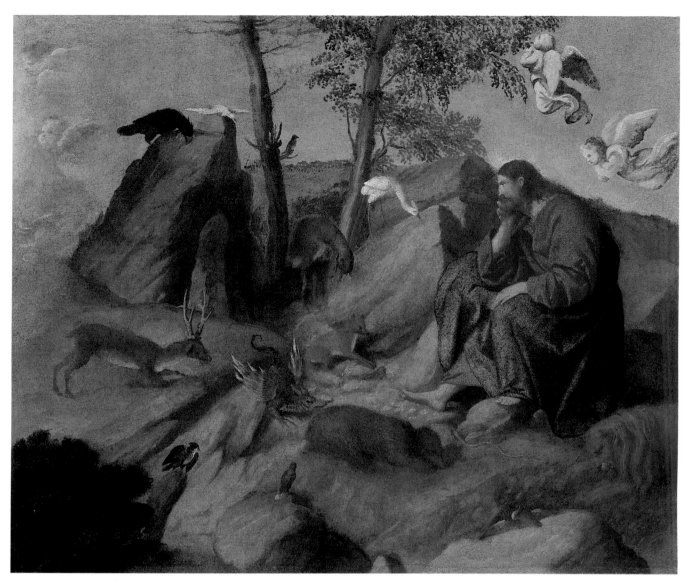

CHRIST IN THE WILDERNESS
Moretto da Brescia

AND Jesus being full of the Holy Ghost returned from Jordan, and was led by the Spirit into the wilderness, Being forty days tempted of the devil. And in those days he did eat nothing: and when they were ended, he afterward hungered.

LUKE 4: 1–2

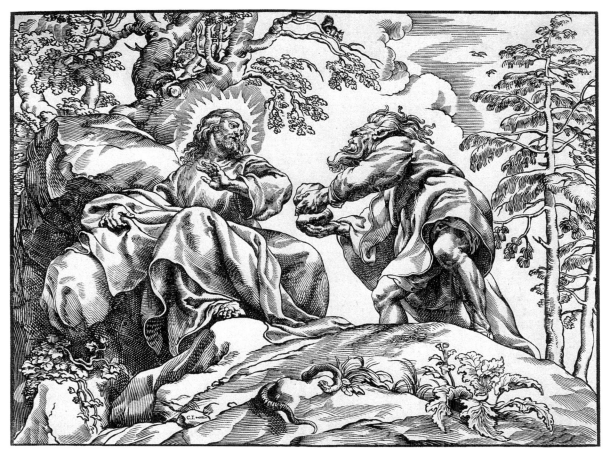

THE TEMPTATION OF CHRIST
C. Jegher, after Rubens

A ND the devil said unto him, If thou be the Son of God, command this stone that it be made bread. And Jesus answered him, saying, It is written, That man shall not live by bread alone, but by every word of God. And the devil, taking him up into an high mountain, shewed unto him all the kingdoms of the world in a moment of time. And the devil said unto him, All this power will I give thee, and the glory of them: for that is delivered unto me; and to whomsoever I will I give it. If thou therefore wilt worship me, all shall be thine. And Jesus answered and said unto him, Get thee behind me, Satan: for it is written, Thou shalt worship the Lord thy God, and him only shalt thou serve.

LUKE 4: 3–8

AND Jesus went about all Galilee, teaching in their synagogues, and preaching the gospel of the kingdom, and healing all manner of sickness and all manner of disease among the people.

MATTHEW 4: 23

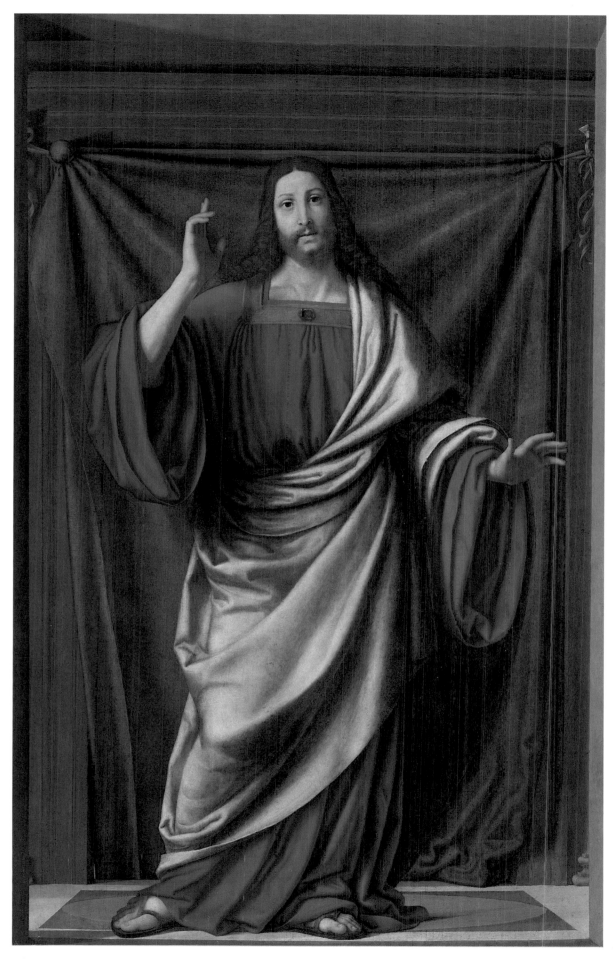

CHRIST BLESSING
Andrea Solario

AND the third day there was a marriage in Cana of Galilee; and the mother of Jesus was there: And both Jesus was called, and his disciples, to the marriage. And when they wanted wine, the mother of Jesus saith unto him, They have no wine. Jesus saith unto her, Woman, what have I to do with thee? mine hour is not yet come. His mother saith unto the servants, Whatsoever he saith unto you, do *it*. And there were set there six waterpots of stone, after the manner of the purifying of the Jews, containing two or three firkins apiece. Jesus saith unto them, Fill the waterpots with water. And they filled them up to the brim. And he saith unto them, Draw out now, and bear unto the governor of the feast. And they bare *it*. When the ruler of the feast had tasted the water that was made wine, and knew not whence it was: (but the servants which drew the water knew;) the governor of the feast called the bridegroom, And saith unto him, Every man at the beginning doth set forth good wine; and when men have well drunk, then that which is worse: *but* thou hast kept the good wine until now. This beginning of miracles did Jesus in Cana of Galilee, and manifested forth his glory; and his disciples believed on him.

JOHN 2: 1–11

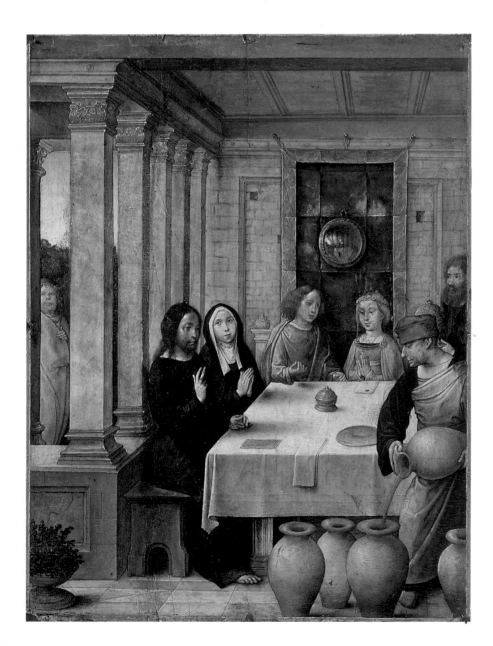

THE MARRIAGE FEAST AT CANA
Juan des Flandes

ow Jacob's well was there. Jesus therefore, being wearied with *his* journey, sat thus
on the well: *and* it was about the sixth hour. There cometh a woman of Samaria to
draw water: Jesus saith unto her, Give me to drink. (For his disciples were gone
away unto the city to buy meat.) Then saith the woman of Samaria unto him, How is it that
thou, being a Jew, askest drink of me, which am a woman of Samaria? for the Jews have no
dealings with the Samaritans. Jesus answered and said unto her, If thou knewest the gift of
God, and who it is that saith to thee, Give me to drink; thou wouldest have asked of him, and
he would have given thee living water. The woman saith unto him, Sir, thou hast nothing to
draw with, and the well is deep: from whence then hast thou that living water? Art thou
greater than our father Jacob, which gave us the well, and drank thereof himself, and his
children, and his cattle? Jesus answered and said unto her, Whosoever drinketh of this water
shall thirst again: But whosoever drinketh of the water that I shall give him shall never
thirst; but the water that I shall give him shall be in him a well of water springing up into
everlasting life.

JOHN 4: 6–14

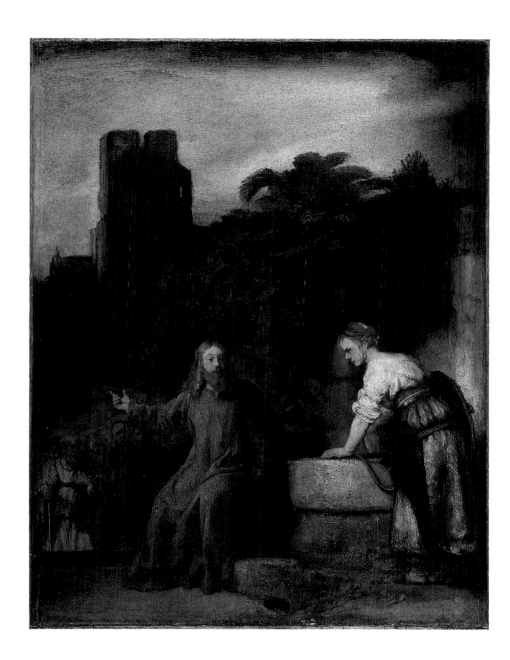

CHRIST AND THE WOMAN
OF SAMARIA
Rembrandt

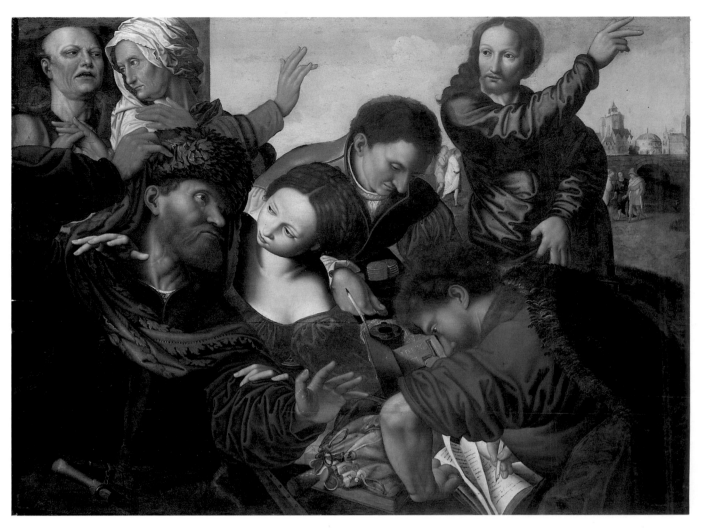

THE CALLING OF MATTHEW
Jan van Hemessen

A ND as Jesus passed forth from thence, he saw a man, named
Matthew, sitting at the receipt of custom: and he saith unto him, Follow me.
And he arose, and followed him.

MATTHEW 9: 9

ND Jesus went about all Galilee, teaching in their synagogues, and preaching the gospel of the kingdom, and healing all manner of sickness and all manner of disease among the people. And his fame went throughout all Syria: and they brought unto him all sick people that were taken with divers diseases and torments, and those which were possessed with devils, and those which were lunatick, and those that had the palsy; and he healed them. And there followed him great multitudes of people from Galilee, and *from* Decapolis, and *from* Jerusalem, and *from* Judaea, and *from* beyond Jordan.

MATTHEW 4: 23–25

FOREST LANDSCAPE WITH TWO OF CHRIST'S MIRACLES
David Vinckboons

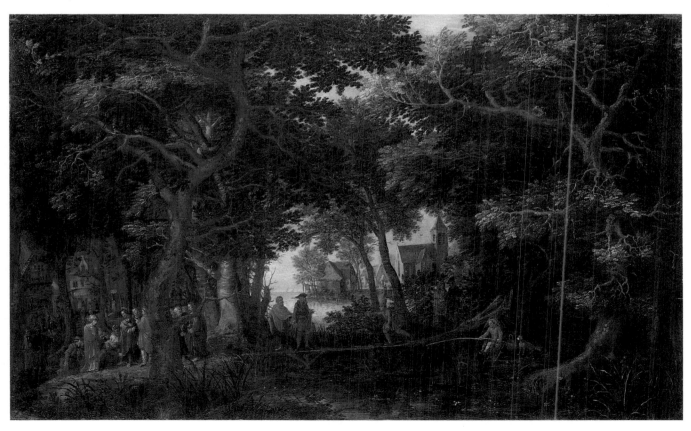

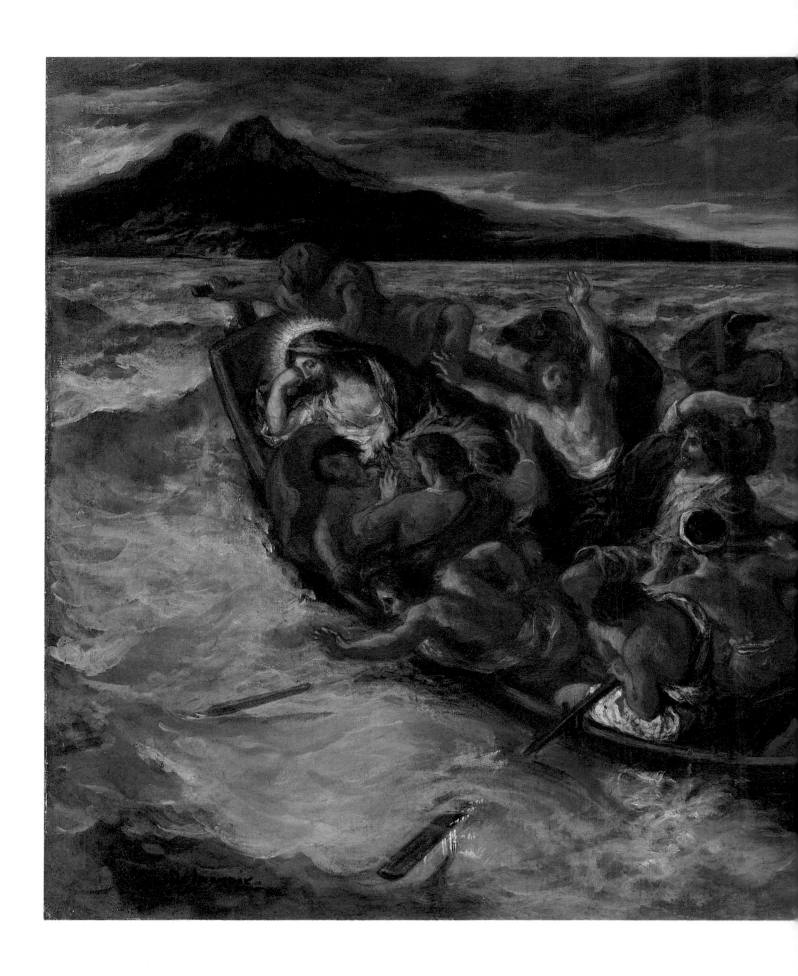

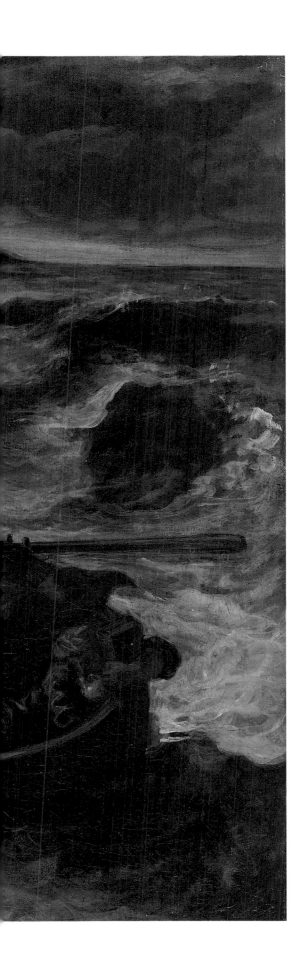

Now it came to pass on a certain day, that he went into a ship with his disciples: and he said unto them, Let us go over unto the other side of the lake. And they launched forth. But as they sailed he fell asleep: and there came down a storm of wind on the lake: and they were filled *with water*, and were in jeopardy.

LUKE 8: 22–23

CHRIST ON THE LAKE OF GENNESARET
Eugène Delacroix

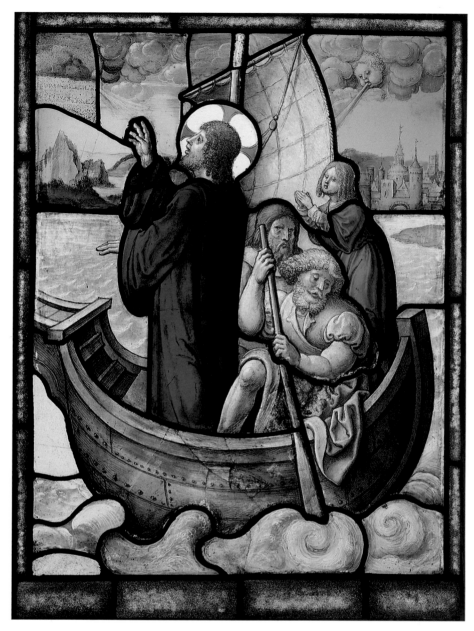

CHRIST STILLS THE TEMPEST
Workshop of Dirk Vellert

ND they came to him, and awoke him, saying, Master, master, we
perish. Then he arose, and rebuked the wind and the raging of the
water: and they ceased, and there was a calm. And he said unto
them, Where is your faith? And they being afraid wondered, saying one to
another, What manner of man is this! for he commandeth even the winds
and water, and they obey him.

LUKE 8: 24–25

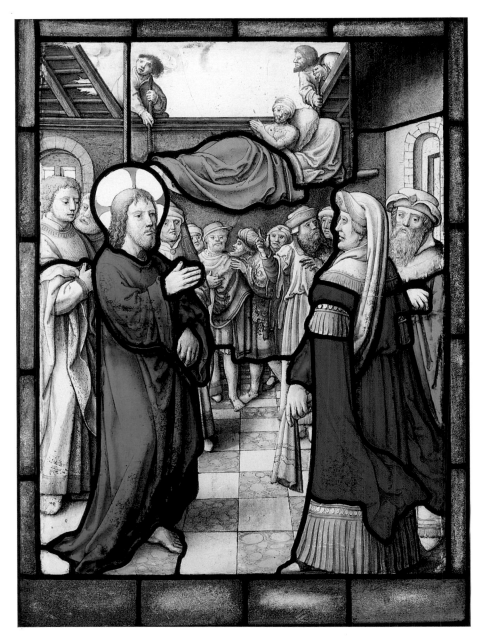

THE HEALING OF THE PARALYTIC AT CAPERNAUM
Workshop of Dirk Vellert

A ND, behold, they brought to him a man sick of the palsy, lying on a bed: and Jesus seeing their faith said unto the sick of the palsy; Son, be of good cheer; thy sins be forgiven thee. And, behold, certain of the scribes said within themselves, This *man* blasphemeth. And Jesus knowing their thoughts said, Wherefore think ye evil in your hearts? For whether is easier, to say, *Thy* sins be forgiven thee; or to say, Arise, and walk? But that ye may know that the Son of man hath power on earth to forgive sins, (then saith he to the sick of the palsy,) Arise, take up thy bed, and go unto thine house. And he arose, and departed to his house. But when the multitudes saw *it*, they marvelled, and glorified God, which had given such power unto men.

MATTHEW 9: 2–8

A T that time Herod the tetrarch heard of the fame of Jesus, and said unto his servants, This is John the Baptist; he is risen from the dead; and therefore mighty works do shew forth themselves in him. For Herod had laid hold on John, and bound him, and put *him* in prison for Herodias' sake, his brother Philip's wife. For John said unto him, It is not lawful for thee to have her. And when he would have put him to death, he feared the multitude, because they counted him as a prophet. But when Herod's birthday was kept, the daughter of Herodias danced before them, and pleased Herod.

MATTHEW 14: 1–11

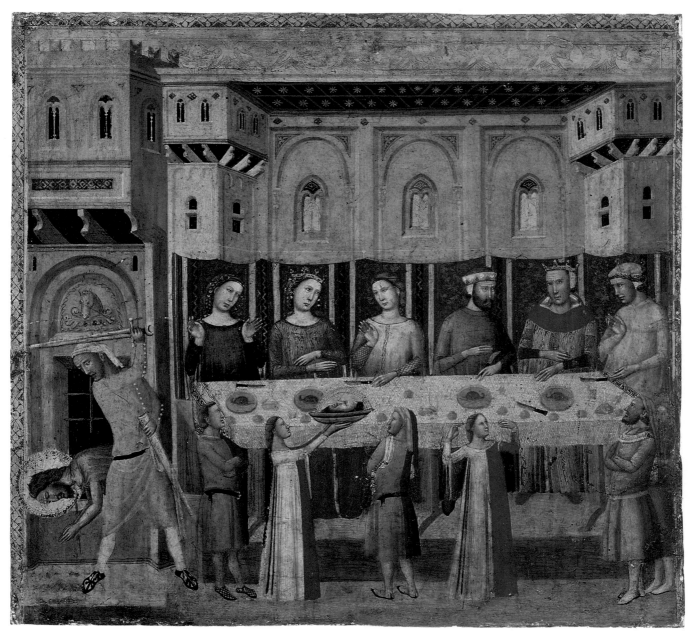

THE FEAST OF HEROD
Unknown Italian painter

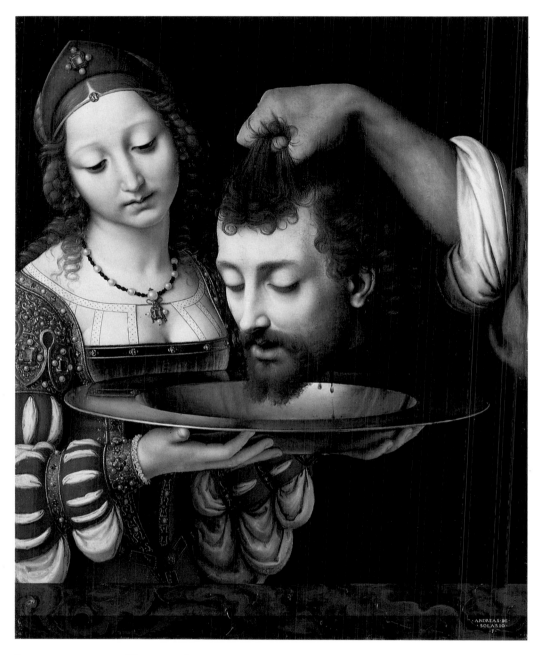

SALOME WITH THE HEAD OF SAINT JOHN THE BAPTIST
Andrea Solario

A ND when the daughter of the said Herodias came in, and danced, and
pleased Herod and them that sat with him, the king said unto the damsel,
Ask of me whatsoever thou wilt, and I will give *it* thee.... And she went
forth, and said unto her mother, What shall I ask? And she said, The head of John
the Baptist. And she came in straightway with haste unto the king, and asked,
saying, I will that thou give me by and by in a charger the head of John the Baptist.

MARK 6: 22, 24–25

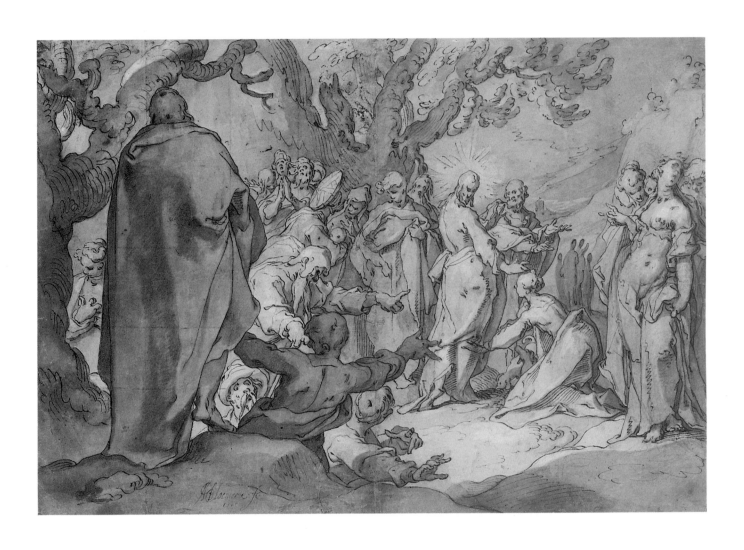

THEN Jesus went thence, and departed into the coasts of Tyre and Sidon. And, behold, a woman of Canaan came out of the same coasts, and cried unto him, saying, Have mercy on me, O Lord, *thou* son of David; my daughter is grievously vexed with a devil. But he answered her not a word. And his disciples came and besought him, saying, Send her away; for she crieth after us. But he answered and said, I am not sent but unto the lost sheep of the house of Israel. Then came she and worshipped him, saying, Lord, help me. But he answered and said, It is not meet to take the children's bread, and to cast *it* to dogs. And she said, Truth, Lord: yet the dogs eat of the crumbs which fall from their masters' table. Then Jesus answered and said unto her, O woman, great *is* thy faith: be it unto thee even as thou wilt. And her daughter was made whole from that very hour.

MATTHEW 15: 21–28

CHRIST AND THE CANAANITE WOMAN
Abraham Bloemaert

AND when it was evening, his disciples came to him, saying, This is a desert place, and the time is now past; send the multitude away, that they may go into the villages, and buy themselves victuals. But Jesus said unto them, They need not depart; give ye them to eat. And they say unto him, We have here but five loaves, and two fishes. He said, Bring them hither to me. And he commanded the multitude to sit down on the grass, and took the five loaves, and the two fishes, and looking up to heaven, he blessed, and brake, and gave the loaves to *his* disciples, and the disciples to the multitude. And they did all eat, and were filled: and they took up of the fragments that remained twelve baskets full. And they that had eaten were about five thousand men, beside women and children.

MATTHEW 14: 15–21

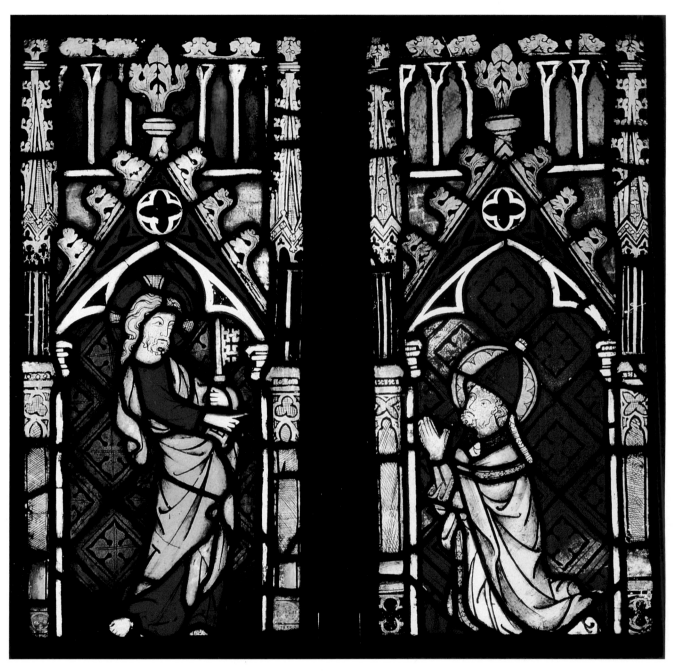

CHRIST PRESENTING THE KEYS TO SAINT PETER
German, 14th century

WHEN Jesus came into the coasts of Caesarea Philippi, he asked his disciples, saying, Whom do men say that I the Son of man am? And they said, Some *say that thou art* John the Baptist: some, Elias; and others, Jeremias, or one of the prophets. He saith unto them, But whom say ye that I am? And Simon Peter answered and said, Thou art the Christ, the Son of the living God. And Jesus answered and said unto him, Blessed art thou, Simon Bar-jona: for flesh and blood hath not revealed *it* unto thee, but my Father which is in heaven. And I say also unto thee, That thou art Peter, and upon this rock I will build my church; and the gates of hell shall not prevail against it. And I will give unto thee the keys of the kingdom of heaven: and whatsoever thou shalt bind on earth shall be bound in heaven: and whatsoever thou shalt loose on earth shall be loosed in heaven.

MATTHEW 16: 13–19

Aᴺᴰ it came to pass about an eight days after these sayings, he took Peter and John and James, and went up into a mountain to pray. And as he prayed, the fashion of his countenance was altered, and his raiment *was* white *and* glistering. And, behold, there talked with him two men, which were Moses and Elias: Who appeared in glory, and spake of his decease which he should accomplish at Jerusalem. But Peter and they that were with him were heavy with sleep: and when they were awake, they saw his glory, and the two men that stood with him.

LUKE 9: 28–32

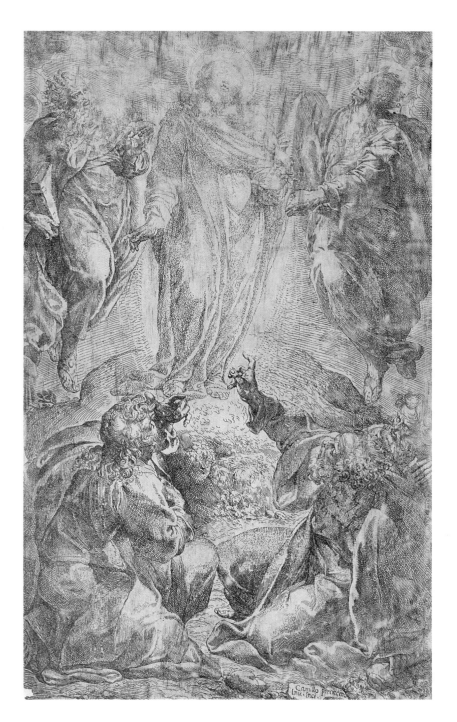

THE TRANSFIGURATION
Camillo Procaccini

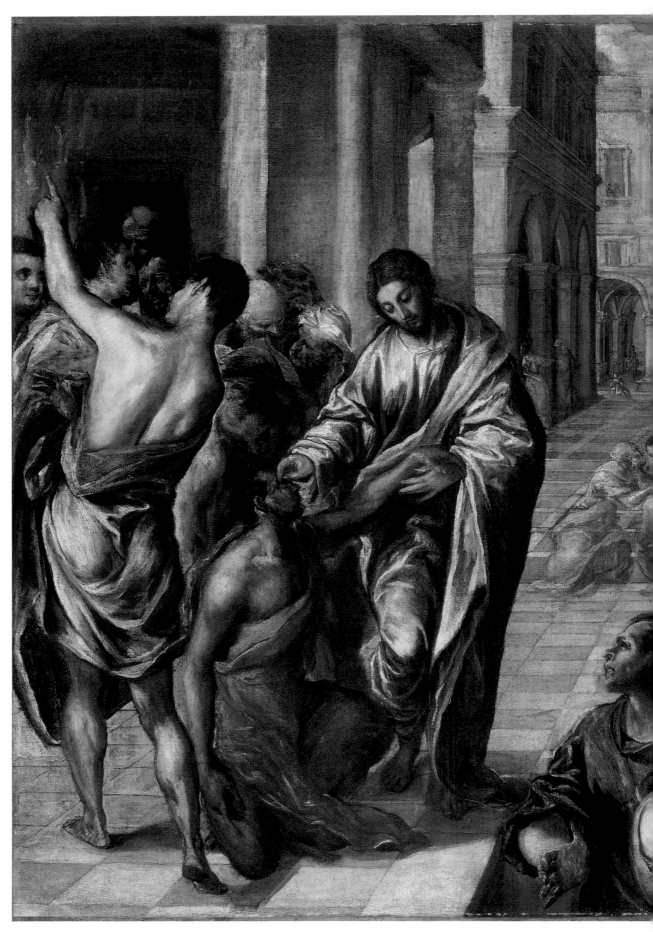

THE MIRACLE OF CHRIST HEALING THE BLIND
El Greco

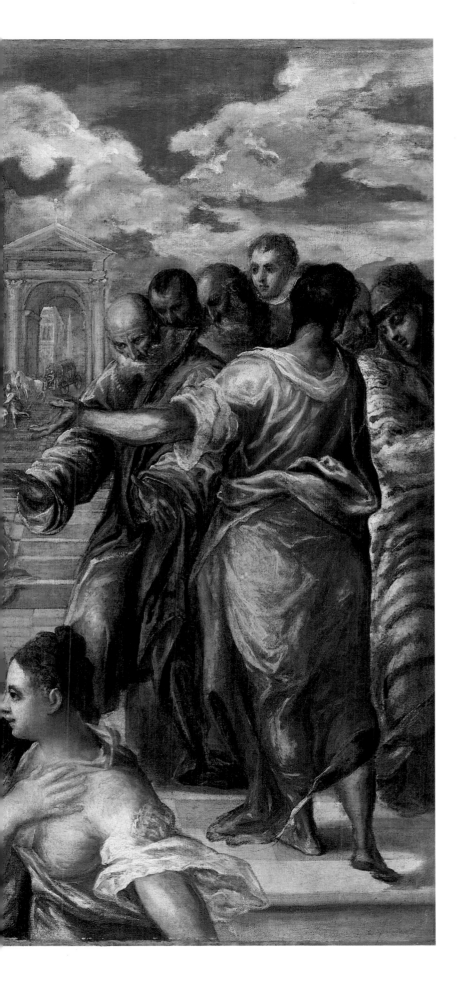

AND they came to Jericho: and as he
went out of Jericho with his disciples
and a great number of people,
blind Bartimaeus, the son of Timaeus, sat
by the highway side begging. And when he
heard that it was Jesus of Nazareth, he
began to cry out, and say, Jesus, *thou* Son of
David, have mercy on me. . . . And Jesus
stood still, and commanded him to be called.
And they call the blind man, saying unto
him, Be of good comfort, rise; he calleth
thee. And he, casting away his garment,
rose, and came to Jesus. And Jesus answered
and said unto him, What wilt thou that I
should do unto thee? The blind man said
unto him, Lord, that I might receive my
sight. And Jesus said unto him, Go thy
way; thy faith hath made thee whole. And
immediately he received his sight, and
followed Jesus in the way.

MARK 10: 46–47, 49–52

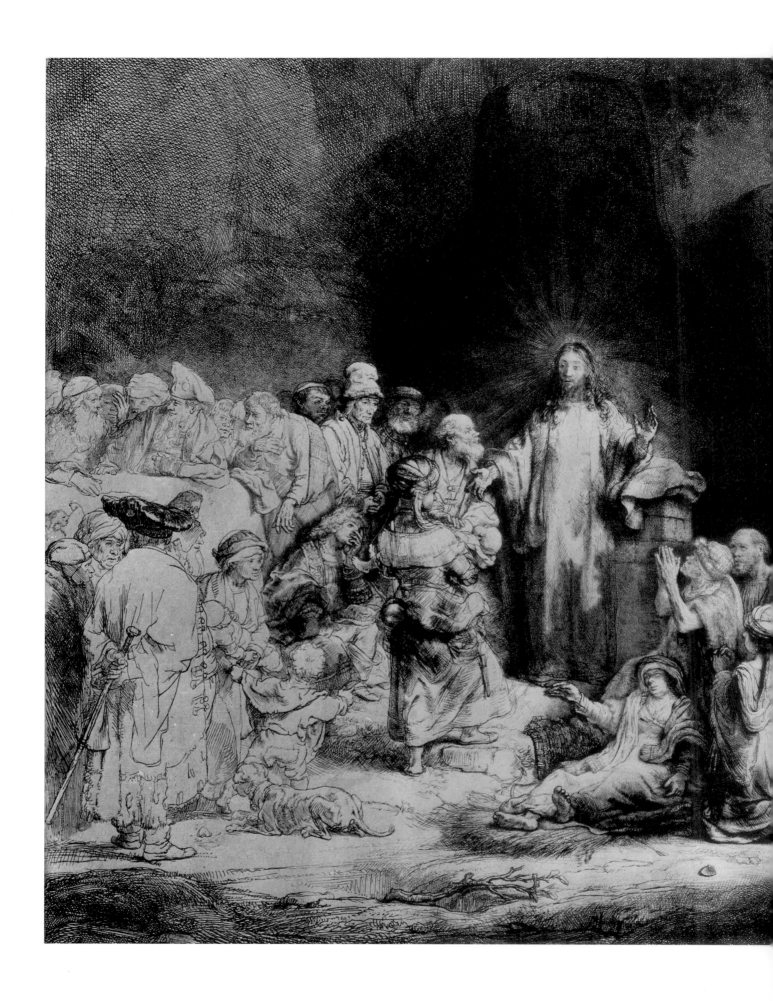

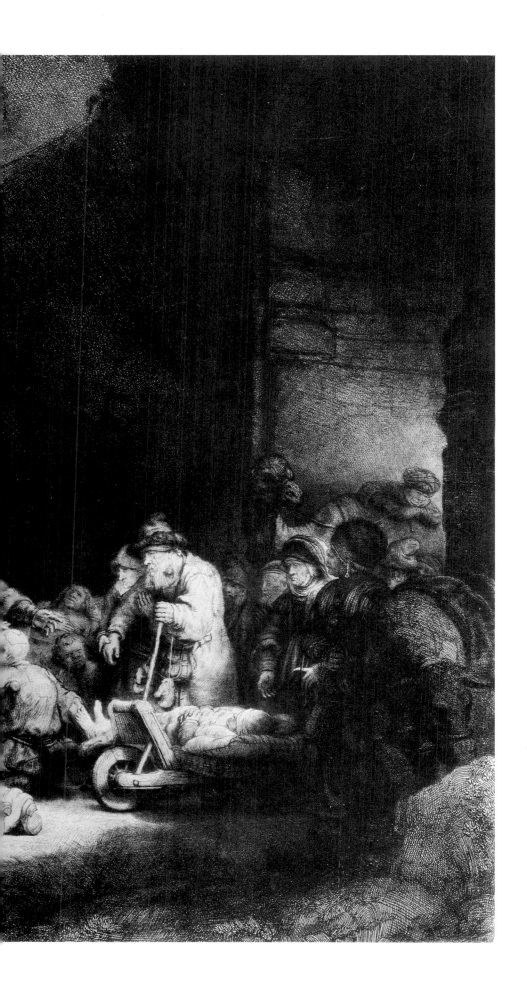

CHRIST HEALING THE SICK
Rembrandt

AND great multitudes came
unto him, having with
them *those that were*
lame, blind, dumb, maimed, and
many others, and cast them down
at Jesus' feet; and he healed
them: Insomuch that the multitude
wondered, when they saw the
dumb to speak, the maimed to be
whole, the lame to walk, and the
blind to see: and they glorified the
God of Israel.

MATTHEW 15: 30–31

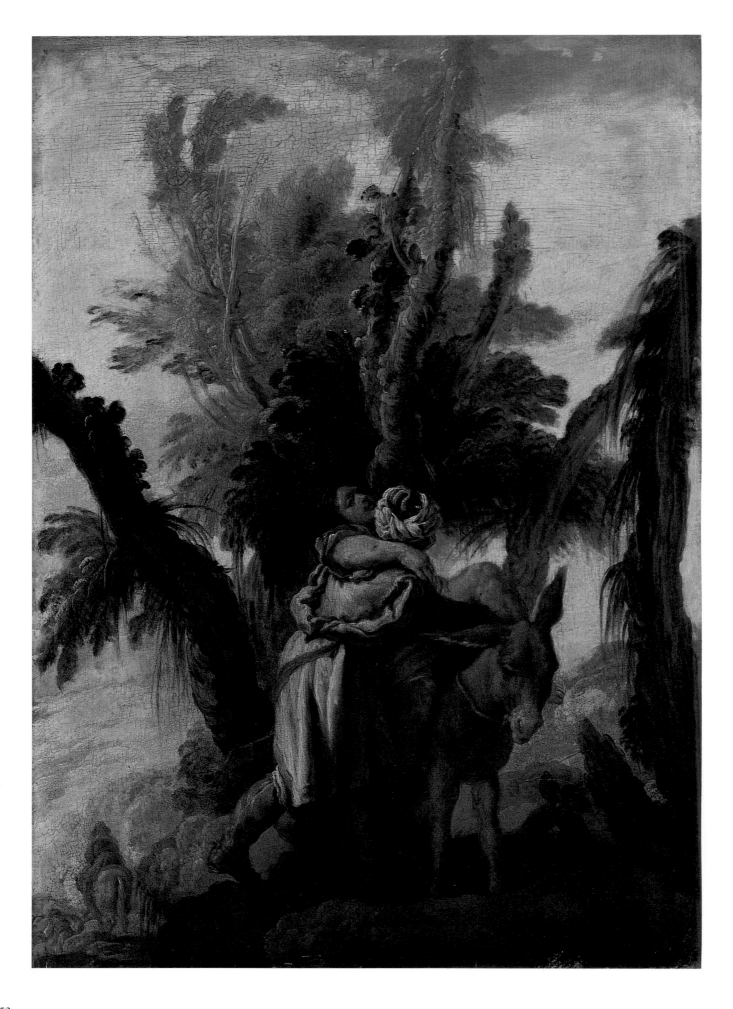

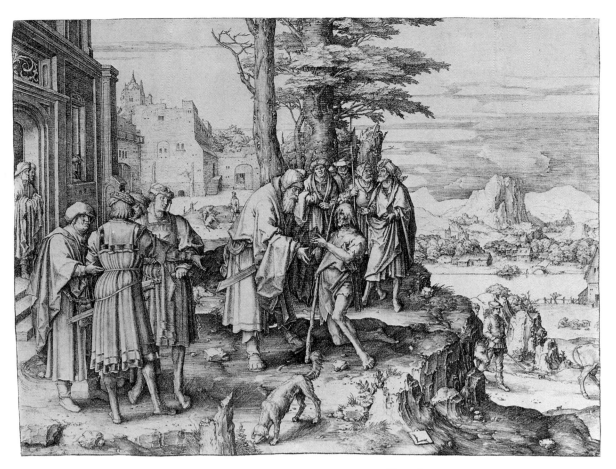

THE RETURN OF THE PRODIGAL SON
Lucas van Leyden

THE GOOD SAMARITAN
Domenico Fetti

AND Jesus answering said, A certain *man* went down from Jerusalem to Jericho, and fell among thieves, which stripped him of his raiment, and wounded *him*, and departed, leaving him half dead. And by chance there came down a certain priest that way: and when he saw him, he passed by on the other side. And likewise a Levite, when he was at the place, came and looked *on him*, and passed by on the other side. But a certain Samaritan, as he journeyed, came where he was: and when he saw him, he had compassion *on him*, And went to *him* and bound up his wounds, pouring in oil and wine, and set him on his own beast, and brought him to an inn, and took care of him.... Which now of these three, thinkest thou, was neighbour unto him that fell among the thieves? And he said, He that shewed mercy on him. Then said Jesus unto him, Go, and do thou likewise.

LUKE 10: 30–34, 36–37

AND he said, A certain man had two sons: And the younger of them said to *his* father, Father, give me the portion of goods that falleth *to me*. And he divided unto them *his* living. And not many days after the younger son gathered all together, and took his journey into a far country, and there wasted his substance with riotous living.... And when he came to himself, he said, How many hired servants of my father's have bread enough and to spare, and I perish with hunger! I will arise and go to my father, and will say unto him, Father, I have sinned against heaven, and before thee, And am no more worthy to be called thy son: make me as one of thy hired servants. And he arose, and came to his father. But when he was yet a great way off, his father saw him, and had compassion, and ran, and fell on his neck, and kissed him.

LUKE 15: 11–13, 17–20

Now it came to pass, as they went, that he entered into a certain village: and a certain woman named Martha received him into her house. And she had a sister called Mary, which also sat at Jesus' feet, and heard his word. But Martha was cumbered about much serving, and came to him, and said, Lord, dost thou not

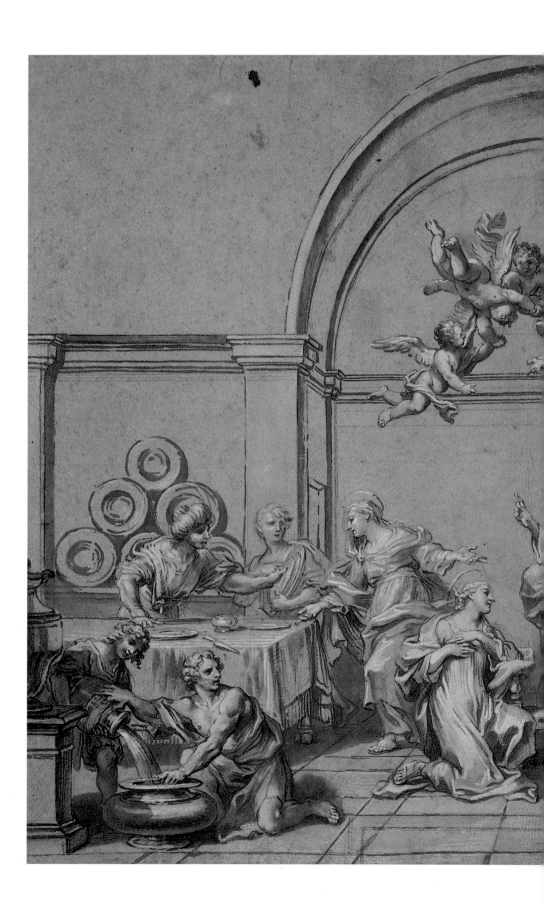

care that my sister hath left me to serve alone? bid her therefore that she help me. And Jesus answered and said unto her, Martha, Martha, thou art careful and troubled about many things: But one thing is needful: and Mary hath chosen that good part, which shall not be taken away from her.

LUKE 10: 38–42

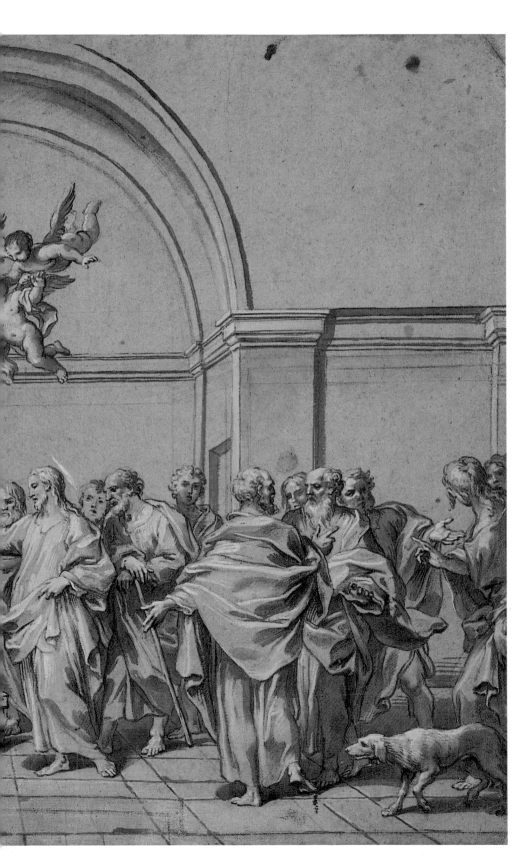

CHRIST IN THE HOUSE OF
MARTHA AND MARY
Paolo Gerolamo Piola

THEN shall the kingdom of heaven be likened unto ten virgins, which took their lamps, and went forth to meet the bridegroom. And five of them were wise, and five *were* foolish. They that *were* foolish took their lamps, and took no oil with them: But the wise took oil in their vessels with their lamps. While the bridegroom tarried, they all slumbered and slept. And at midnight there was a cry made, Behold, the bridegroom cometh; go ye out to meet him. Then all those virgins arose, and trimmed their lamps. And the foolish said unto the wise, Give us of your oil; for our lamps are gone out. But the wise answered, saying, *Not so;* lest there be not enough for us and you: but go ye rather to them that sell, and buy for yourselves. And while they went to buy, the bridegroom came; and they that were ready went in with him to the marriage: and the door was shut. Afterward came also the other virgins, saying, Lord, Lord, open to us. But he answered, and said, Verily I say unto you, I know you not. Watch therefore, for ye know neither the day nor the hour wherein the Son of man cometh.

MATTHEW 25: 1–13

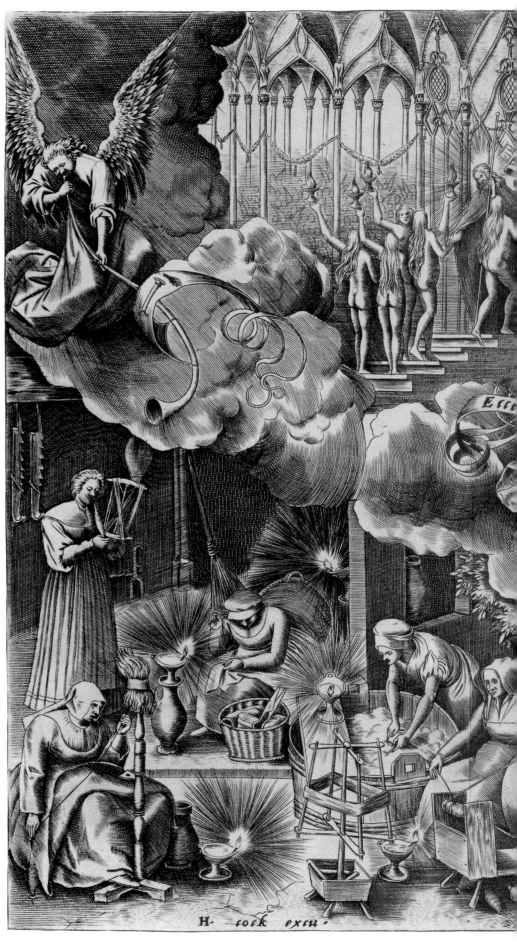

THE WISE AND FOOLISH VIRGINS
Pieter Breughel the Elder

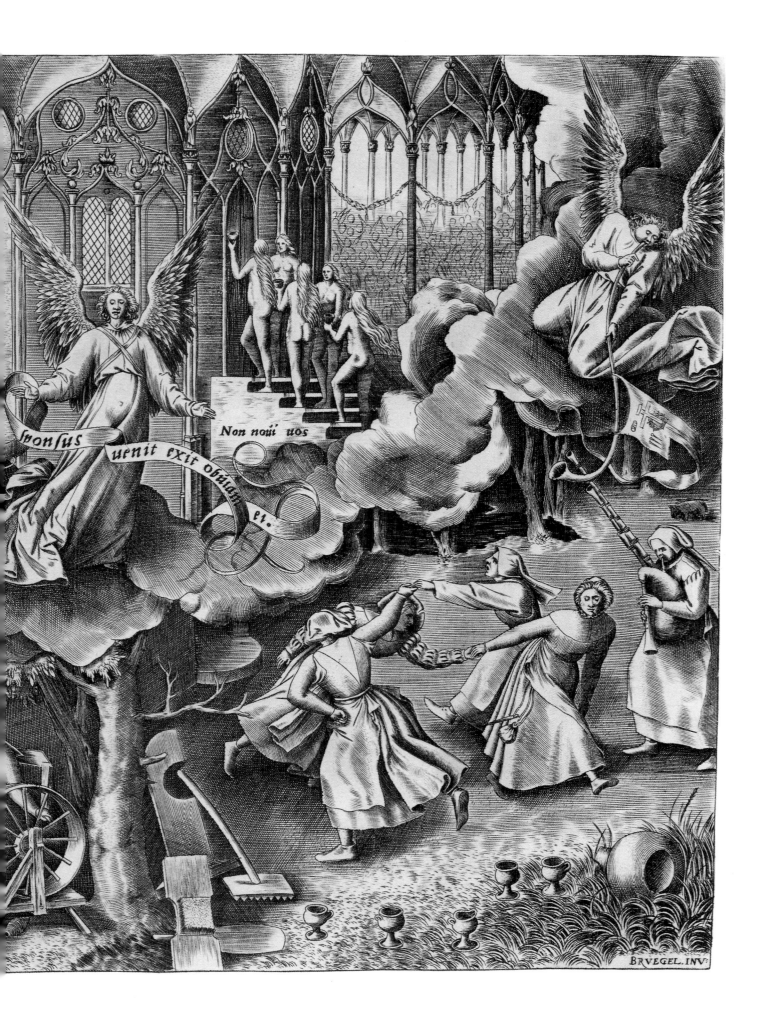

Non noui uos

sponsus uenit exit obuiam ei.

BRVEGEL. INV:

57

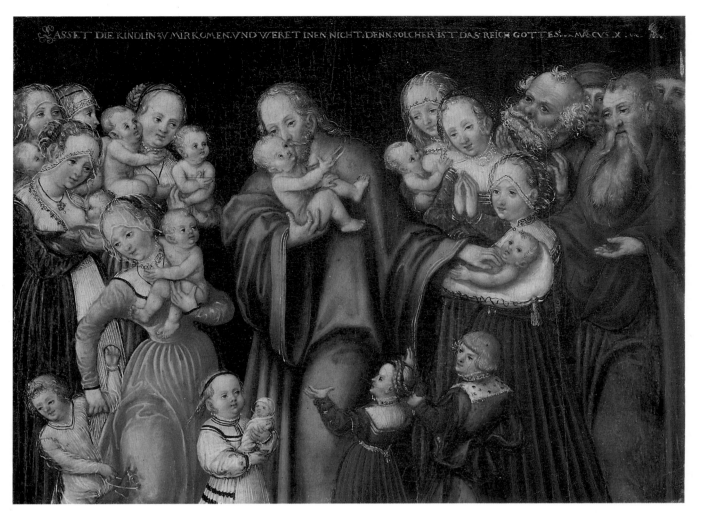

CHRIST BLESSING THE CHILDREN
Lucas Cranach the Elder

A ND they brought unto him also infants, that he would touch them: but when *his* disciples saw *it*, they rebuked them. But Jesus called them *unto him*, and said, Suffer little children to come unto me, and forbid them not: for of such is the kingdom of God. Verily I say unto you, Whosoever shall not receive the kingdom of God as a little child shall in no wise enter therein.

LUKE 18: 15–17

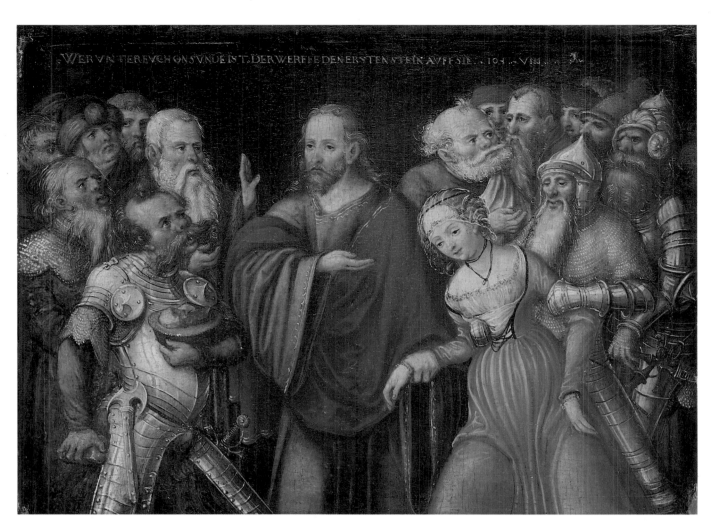

CHRIST AND THE ADULTERESS
Lucas Cranach the Elder

Jesus went unto the mount of Olives. And early in the morning he came again into the temple, and all the people came unto him; and he sat down, and taught them. And the scribes and Pharisees brought unto him a woman taken in adultery; and when they had set her in the midst, They say unto him, Master, this woman was taken in adultery, in the very act. Now Moses in the law commanded us, that such should be stoned: but what sayest thou? This they said, tempting him, that they might have to accuse him. But Jesus stooped down, and with *his* finger wrote on the ground, *as though he heard them not.* So when they continued asking him, he lifted up himself, and said unto them, He that is without sin among you, let him first cast a stone at her. And again he stooped down, and wrote on the ground. And they which heard *it,* being convicted by *their own* conscience, went out one by one, beginning at the eldest, *even* unto the last: and Jesus was left alone, and the woman standing in the midst. When Jesus had lifted up himself, and saw none but the woman, he said unto her, Woman, where are those thine accusers? hath no man condemned thee? She said, No man, Lord. And Jesus said unto her, Neither do I condemn thee: go, and sin no more.

JOHN 8: 1–11

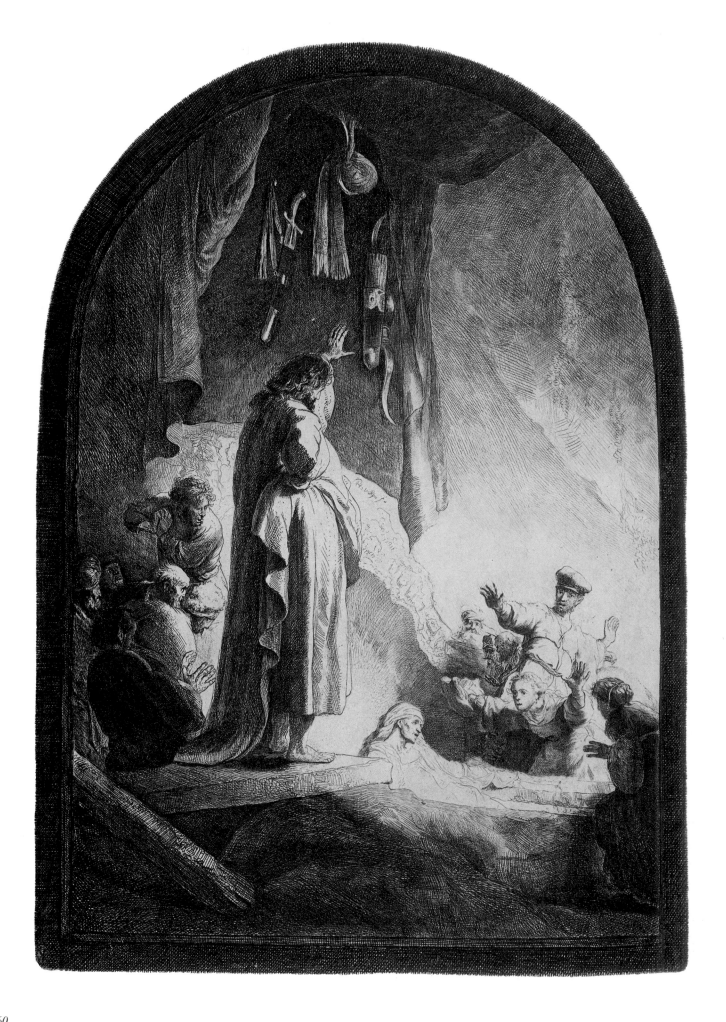

60

MAGDALEN ANOINTING THE FEET OF CHRIST
IN THE HOUSE OF SIMON THE PHARISEE
Maestro Giorgio Andreoli

THE RAISING OF LAZARUS
Rembrandt

THEN they took away the stone *from the place* where the dead was laid. And Jesus lifted up *his* eyes, and said, Father, I thank thee that thou hast heard me. And I knew that thou hearest me always: but because of the people which stand by I said *it*, that they may believe that thou hast sent me. And when he thus had spoken, he cried with a loud voice, Lazarus, come forth. And he that was dead came forth, bound hand and foot with graveclothes: and his face was bound about with a napkin. Jesus saith unto them, Loose him, and let him go.

JOHN 11: 41–44

AND one of the Pharisees desired him that he would eat with him. And he went into the Pharisee's house, and sat down to meat. And, behold, a woman in the city, which was a sinner, when she knew that *Jesus* sat at meat in the Pharisee's house, brought an alabaster box of ointment. And stood at his feet behind *him* weeping, and began to wash his feet with tears, and did wipe *them* with the hairs of her head, and kissed his feet, and anointed *them* with the ointment.

LUKE 7: 36–38

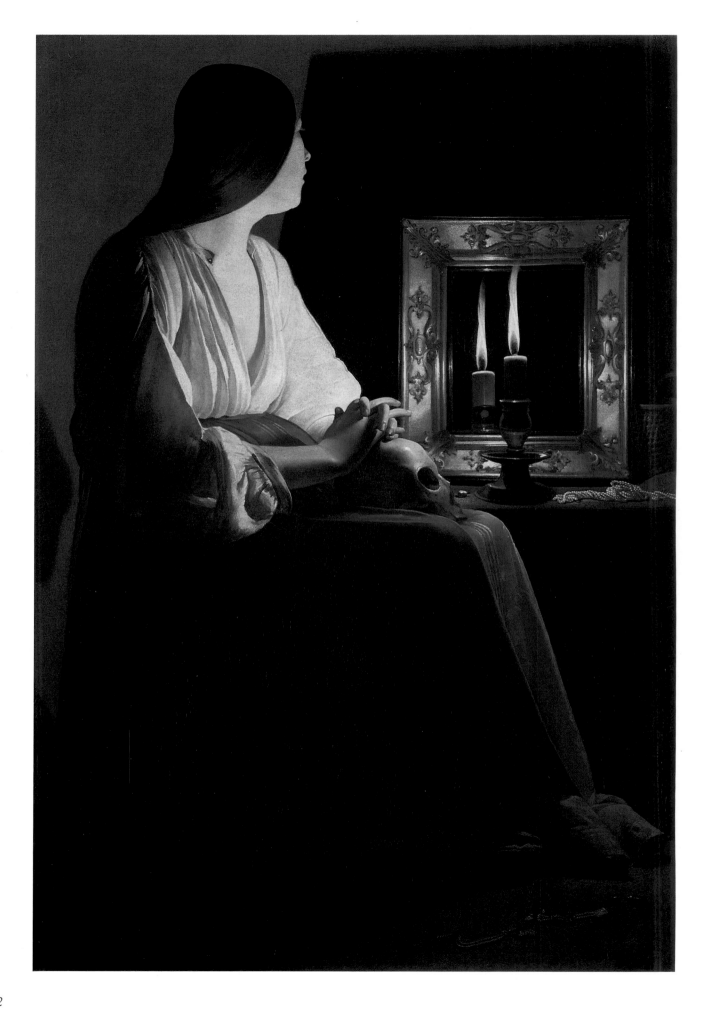

THE PENITENT MAGDALEN
Georges de la Tour

AND he turned to the woman, and said unto Simon, Seest thou this woman? I entered into thine house, thou gavest me no water for my feet: but she hath washed my feet with tears, and wiped *them* with the hairs of her head. Thou gavest me no kiss: but this woman since the time I came in hath not ceased to kiss my feet. My head with oil thou didst not anoint: but this woman hath anointed my feet with ointment. Wherefore I say unto thee, Her sins, which are many, are forgiven; for she loveth much: but to whom little is forgiven, *the same* loveth little. And he said unto her, Thy sins are forgiven.

LUKE 7: 44–48

AND Jesus went into the temple of God, and cast out all them that sold and bought in the temple, and overthrew the tables of the moneychangers, and the seats of them that sold doves, And said unto them, It is written, My house shall be called the house of prayer; but ye have made it a den of thieves. And the blind and the lame came to him in the temple; and he healed them. And when the chief priests and scribes saw the wonderful things that he did, and the children crying in the temple, and saying, Hosanna to the Son of David; they were sore displeased.

MATTHEW 21: 12–15

CHRIST DRIVING THE MONEY CHANGERS
FROM THE TEMPLE
Rembrandt

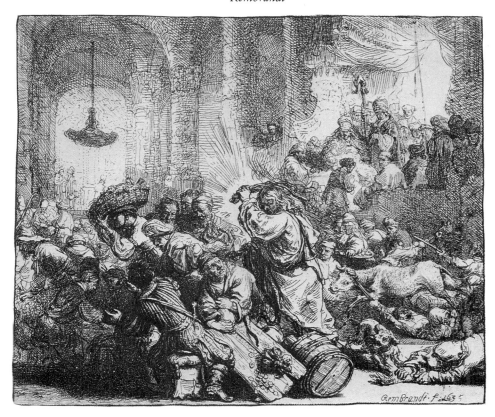

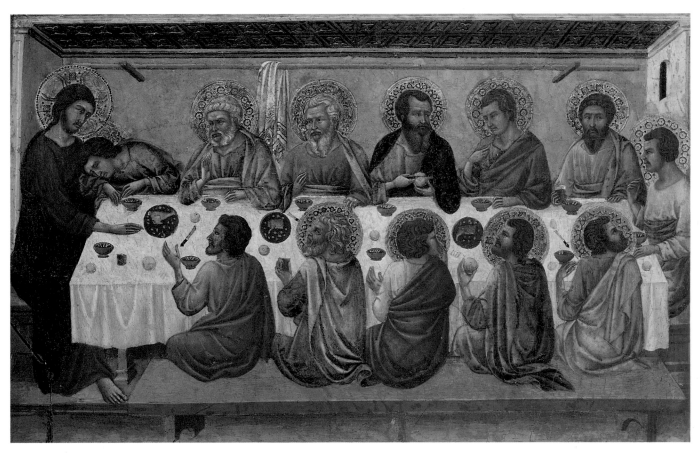

THE LAST SUPPER
Ugolino da Nerio

AND as they were eating, Jesus took bread, and blessed *it*, and brake *it*, and gave *it* to the disciples, and said, Take, eat; this is my body. And he took the cup, and gave thanks, and gave *it* to them, saying, Drink ye all of it; For this is my blood of the new testament, which is shed for many for the remission of sins. But I say unto you, I will not drink henceforth of this fruit of the vine, until that day when I drink it new with you in my Father's kingdom.

MATTHEW 26: 26–29

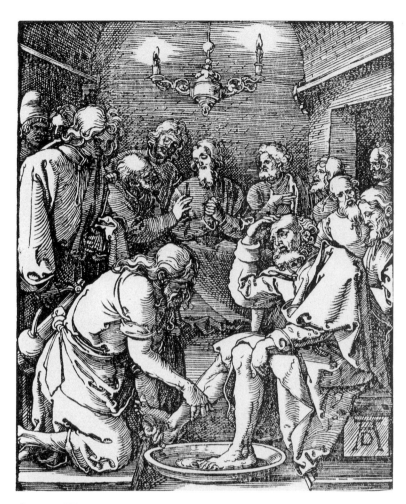

CHRIST WASHING SAINT PETER'S FEET
Albrecht Dürer

For he knew who should betray him; therefore said he, Ye are not all clean. So after he had washed their feet, and had taken his garments, and was set down again, he said unto them, Know ye what I have done to you? Ye call me Master and Lord: and ye say well; for *so* I am. If I then, *your* Lord and Master, have washed your feet; ye also ought to wash one another's feet. For I have given you an example, that ye should do as I have done to you. Verily, verily, I say unto you, The servant is not greater than his lord; neither he that is sent greater than he that sent him.

JOHN 13: 11–16

ND he came out, and went, as he was wont, to the mount of Olives; and his disciples also followed him. And when he was at the place, he said unto them, Pray that ye enter not into temptation. And he was withdrawn from them about a stone's cast, and kneeled down, and prayed, Saying, Father, if thou be willing, remove this cup from me: nevertheless not my will, but thine, be done. And there appeared an angel unto him from heaven, strengthening him. And being in an agony he prayed more earnestly: and his sweat was as it were great drops of blood falling down to the ground. And when he rose up from prayer, and was come to his disciples, he found them sleeping for sorrow, And said unto them, Why sleep ye? rise and pray, lest ye enter into temptation.

LUKE 22: 39–46

THE AGONY IN THE GARDEN
Raphael

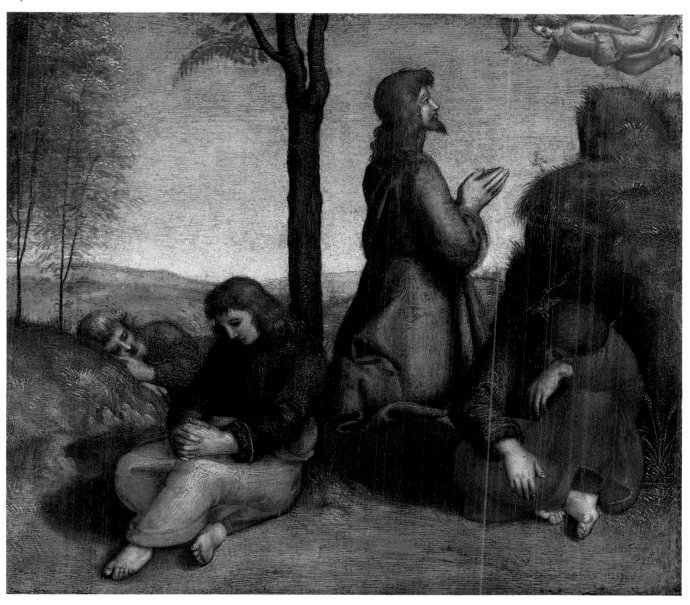

AND immediately, while he yet spake, cometh Judas, one of the twelve, and with him a great multitude with swords and staves, from the chief priests and the scribes and the elders. And he that betrayed him had given them a token, saying, Whomsoever I shall kiss, that same is he; take him, and lead *him* away safely. And as soon as he was come, he goeth straightway to him, and saith, Master, master; and kissed him. And they laid their hands on him, and took him.

MARK 14: 43–46

THE BETRAYAL OF CHRIST
Bartolommeo di Tomasso

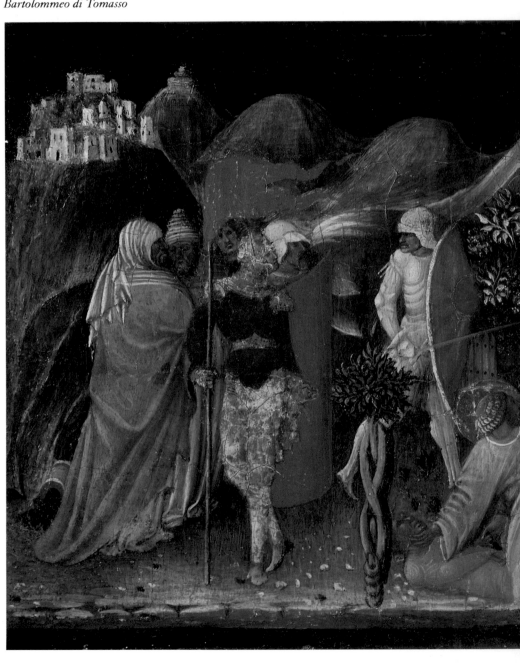

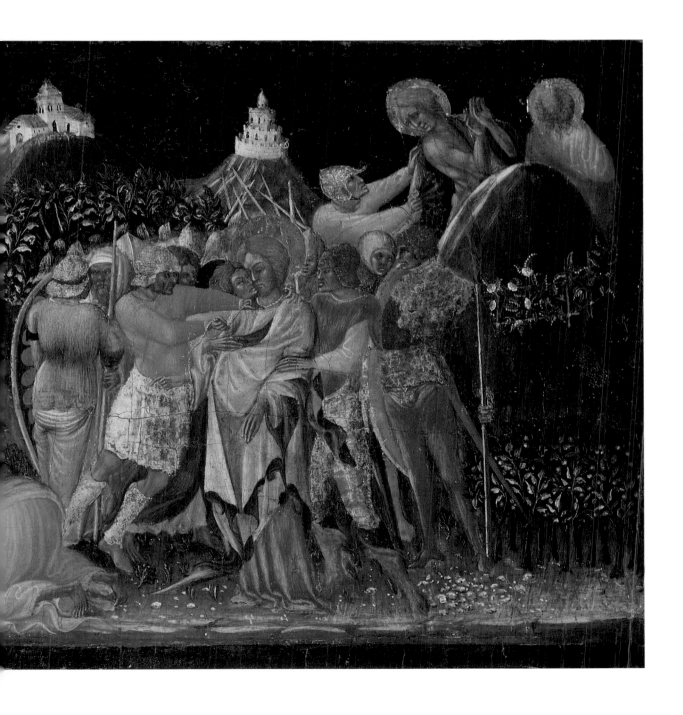

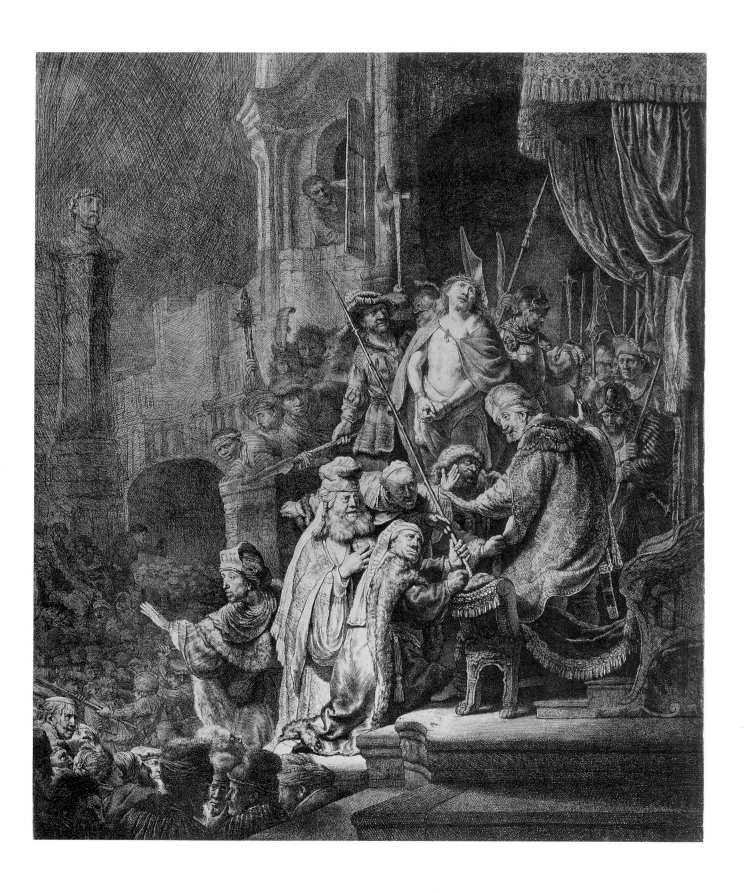

THE DELIVERY OF BARABBAS
The Limbourg Brothers

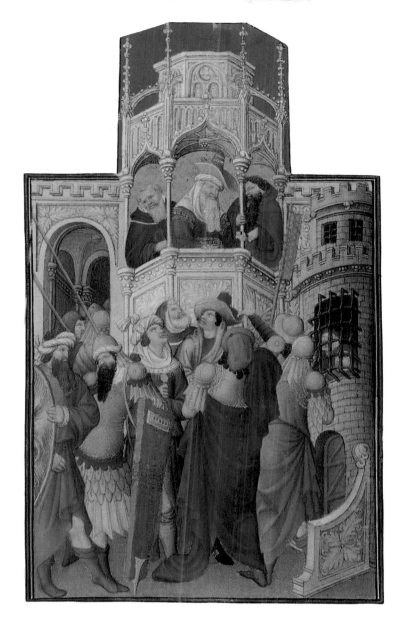

CHRIST BEFORE PILATE
Rembrandt

A ND Pilate, when he had called together the chief priests and the rulers and the people, Said unto them, Ye have brought this man unto me, as one that perverteth the people: and, behold, I, having examined *him* before you, have found no fault in this man touching those things whereof ye accuse him: No, nor yet Herod: for I sent you to him; and, lo, nothing worthy of death is done unto him. I will therefore chastise him, and release *him*.... And they cried out all at once, saying, Away with this *man*, and release unto us Barabbas:... Pilate therefore, willing to release Jesus, spake again to them. But they cried, saying, Crucify *him*, crucify him.... And Pilate gave sentence that it should be as they required.

LUKE 23: 13–16, 18, 20–21, 24

N ow at *that* feast the governor was wont to release unto the people a prisoner whom they would. And they had then a notable prisoner, called Barabbas. Therefore when they were gathered together, Pilate said unto them, Whom will ye that I release unto you? Barabbas, or Jesus which is called Christ? For he knew that for envy they had delivered him. When he was set down on the judgment seat, his wife sent unto him, saying, Have thou nothing to do with that just man: for I have suffered many things this day in a dream because of him. But the chief priests and elders persuaded the multitude that they should ask Barabbas, and destroy Jesus.

MATTHEW 27: 15–20

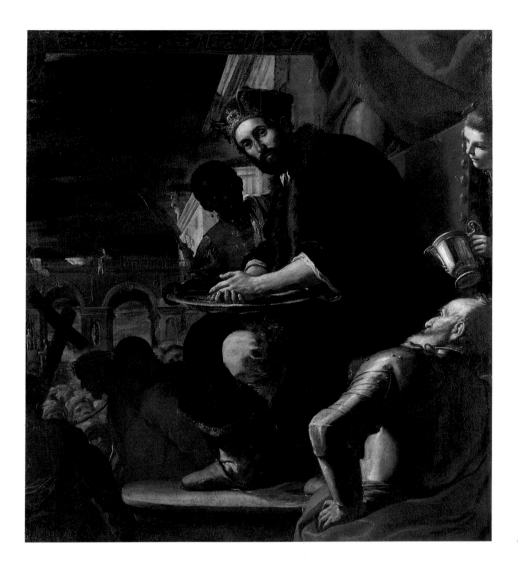

PILATE WASHING HIS HANDS
Mattia Preti

PILATE saith unto them, What shall I do then with Jesus which is called Christ? *They* all say unto him, Let him be crucified. And the governor said, Why, what evil hath he done? But they cried out the more, saying, Let him be crucified. When Pilate saw that he could prevail nothing, but *that* rather a tumult was made, he took water, and washed *his* hands before the multitude, saying, I am innocent of the blood of this just person: see ye *to it*. Then answered all the people, and said, His blood *be* on us, and on our children.

MATTHEW 27: 22–25

THE MOCKING OF CHRIST/THE FLAGELLATION
Unknown English painter

AND they clothed him with purple, and platted a crown of thorns, and put it about his *head*, And began to salute him, Hail, King of the Jews! And they smote him on the head with a reed, and did spit upon him, and bowing *their* knees worshipped him. And when they had mocked him, they took off the purple from him, and put his own clothes on him, and led him out to crucify him.

MARK 15: 17–20

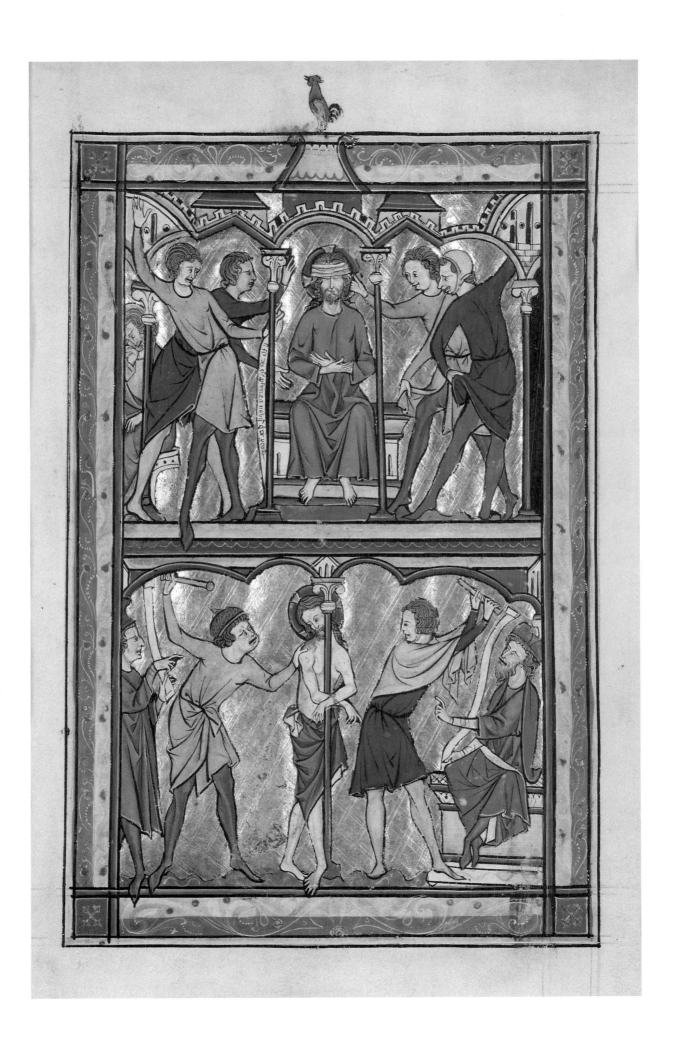

PILATE therefore went forth again, and saith unto them, Behold, I bring him forth to you, that ye may know that I find no fault in him. Then came Jesus forth, wearing the crown of thorns, and the purple robe. And *Pilate* saith unto them, Behold the man!

JOHN 19: 4–5

THEN delivered he him therefore unto them to be crucified. And they took Jesus, and led *him* away. And he bearing his cross went forth into a place called *the place* of a skull, which is called in the Hebrew Golgotha.

JOHN 19: 16–17

ECCE HOMO
Unknown German sculptor

CHRIST CARRYING THE CROSS
El Greco

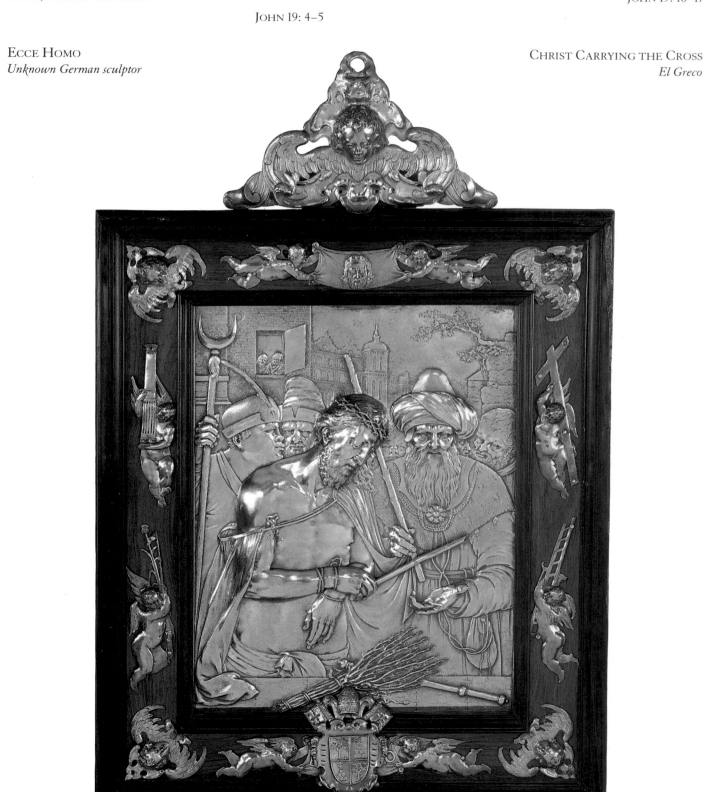

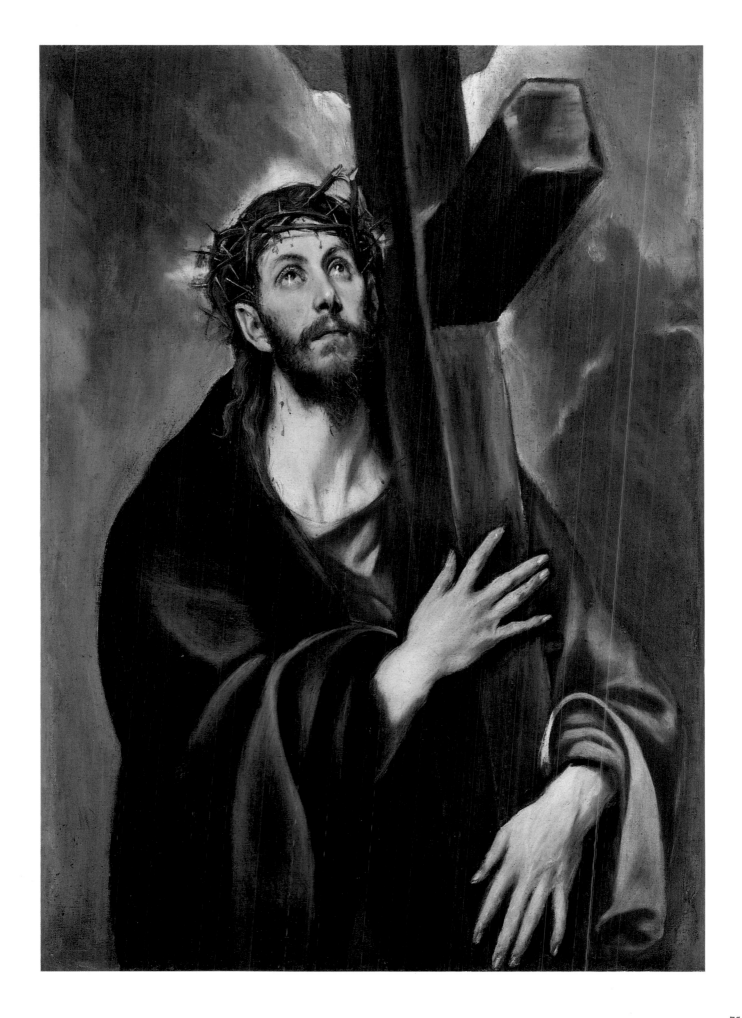

AND there followed him a great company of people, and of women, which also bewailed and lamented him. But Jesus turning unto them said, Daughters of Jerusalem, weep not for me, but weep for yourselves, and for your children.

LUKE 23: 27–28

THE ROAD TO CALVARY
Martin Schöngauer

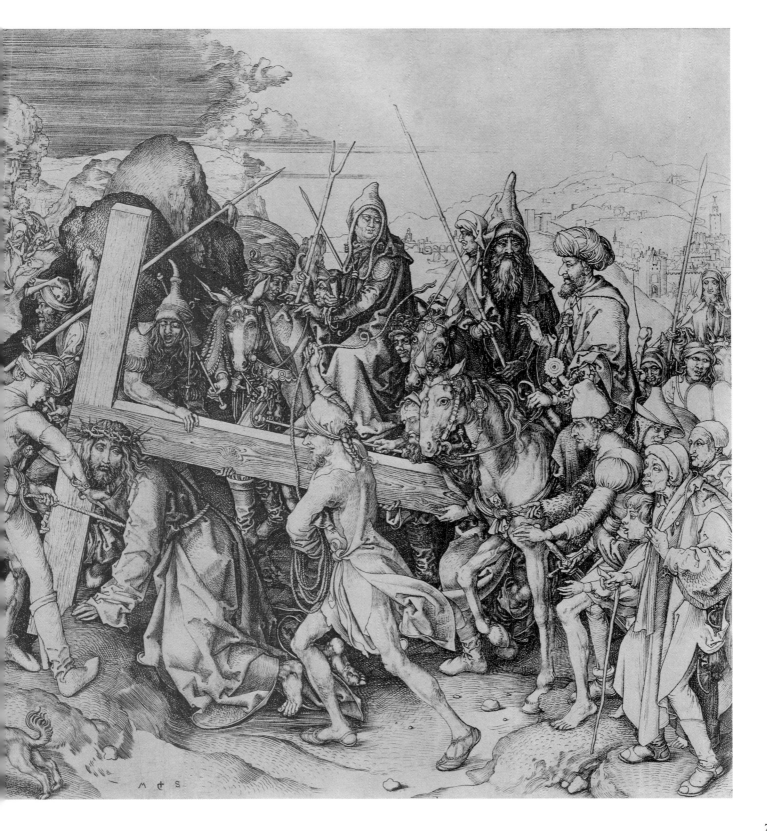

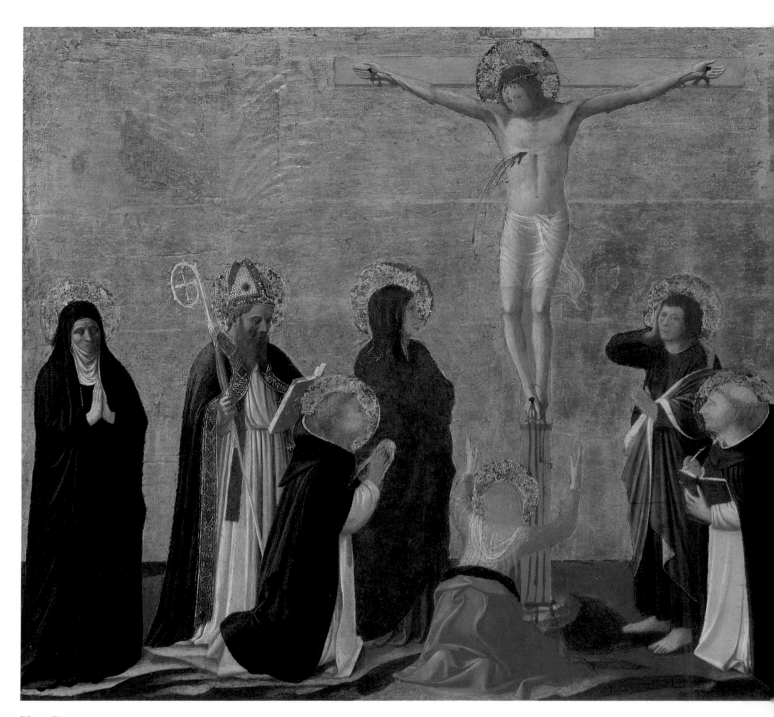

THE CRUCIFIXION
Fra Angelico

A<small>ND</small> it was about the sixth hour, and there was a darkness over all the earth until the ninth hour.

<div align="right">

L<small>UKE</small> 23: 44

</div>

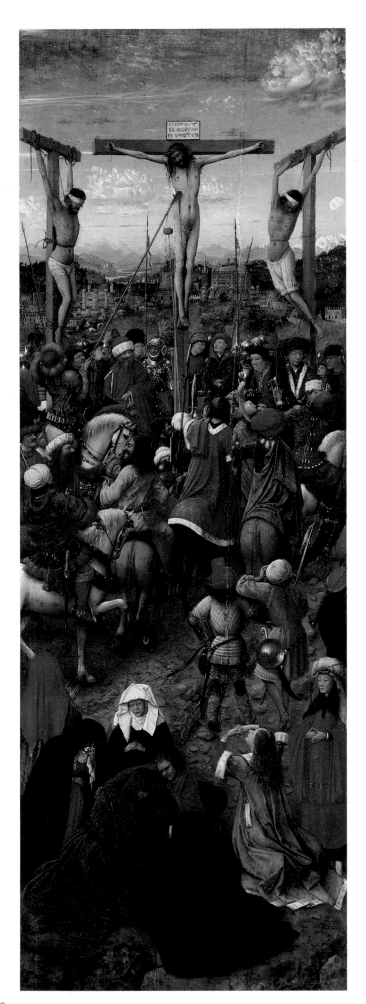

AND when they were come to the place,
which is called Calvary, there they
crucified him, and the malefactors,
one on the right hand, and the other on the
left. Then said Jesus, Father, forgive them; for
they know not what they do. And they parted
his raiment, and cast lots.

<div align="right">LUKE 23: 33–34</div>

THE CRUCIFIXION
Jan van Eyck

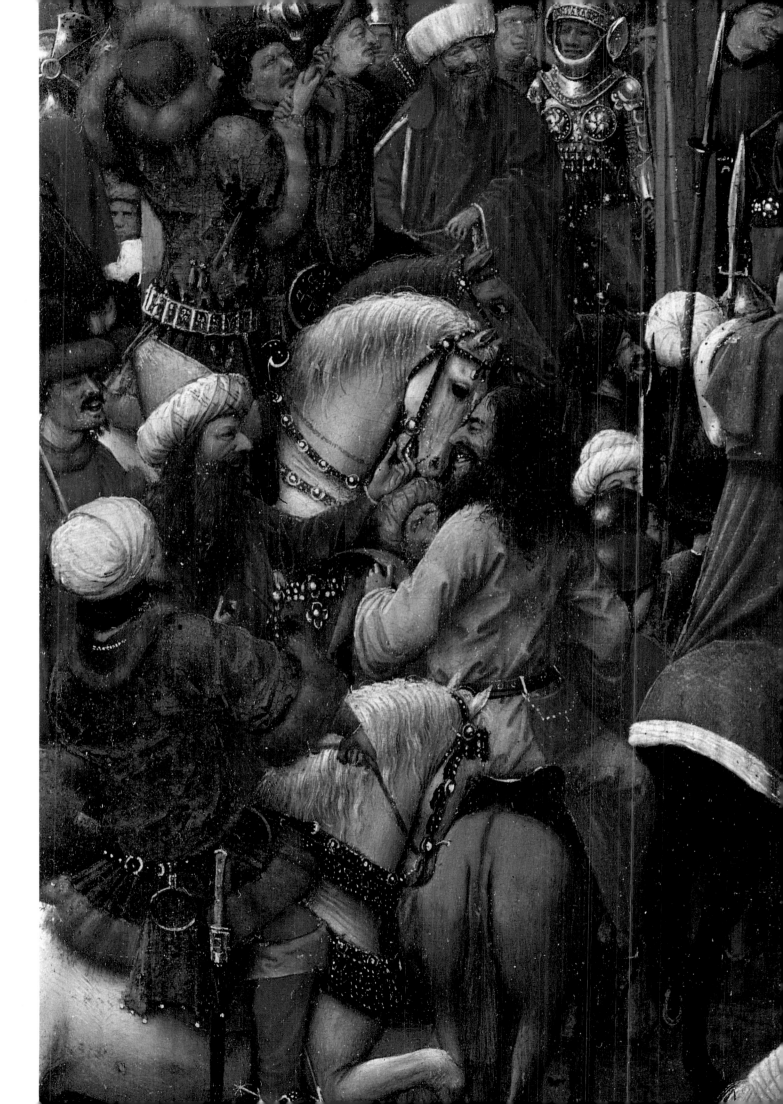

And when they had fulfilled all that was written of him,
they took *him* down from the tree, and laid *him* in a sepulchre.

<div align="right">Acts 13: 29</div>

<div align="right">

Descent from the Cross
Unknown French sculptor

</div>

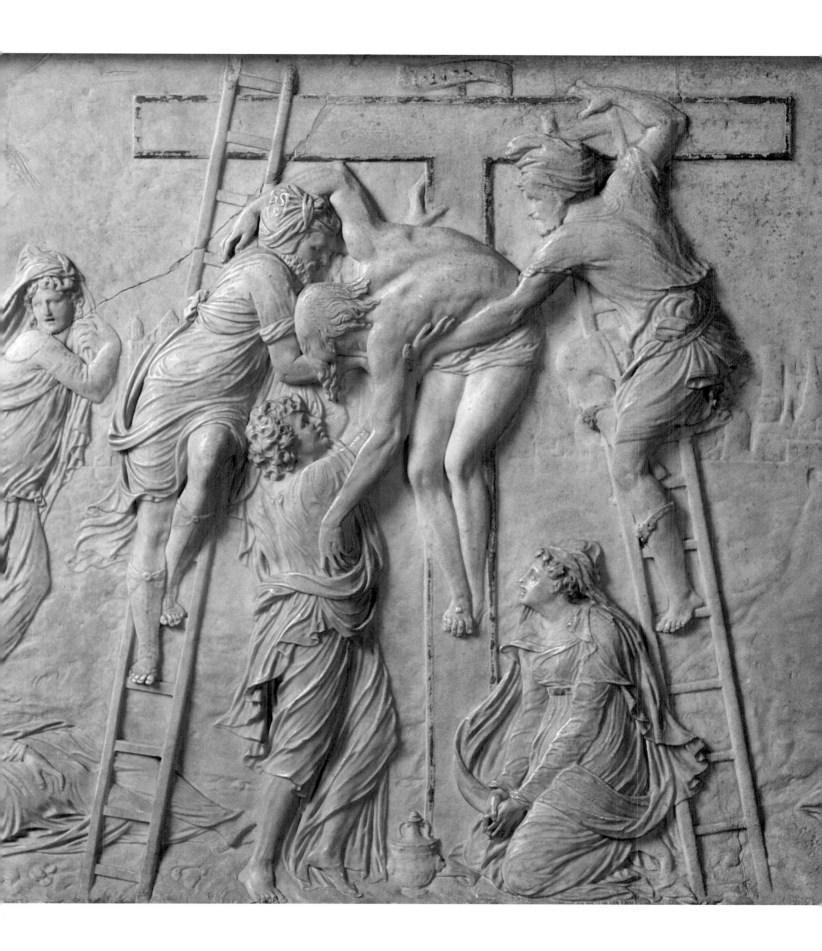

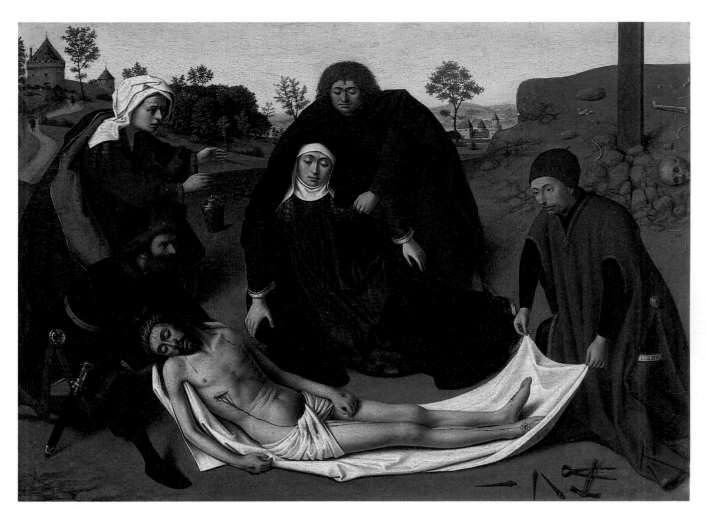

THE LAMENTATION
Petrus Christus

And the women also, which came with him from Galilee, followed after, and beheld the sepulchre, and how his body was laid.

LUKE 23: 55

THE ENTOMBMENT
Moretto da Brescia

And after this Joseph of Arimathaea, being a disciple of Jesus, but secretly for fear of the Jews, besought Pilate that he might take away the body of Jesus: and Pilate gave *him* leave. He came therefore, and took the body of Jesus. And there came also Nicodemus, which at the first came to Jesus by night, and brought a mixture of myrrh and aloes, about an hundred pound *weight*. Then took they the body of Jesus, and wound it in linen clothes with the spices, as the manner of the Jews is to bury. Now in the place where he was crucified there was a garden; and in the garden a new sepulchre, wherein was never man yet laid. There laid they Jesus therefore because of the Jews' preparation *day*; for the sepulchre was nigh at hand.

JOHN 19: 38–42

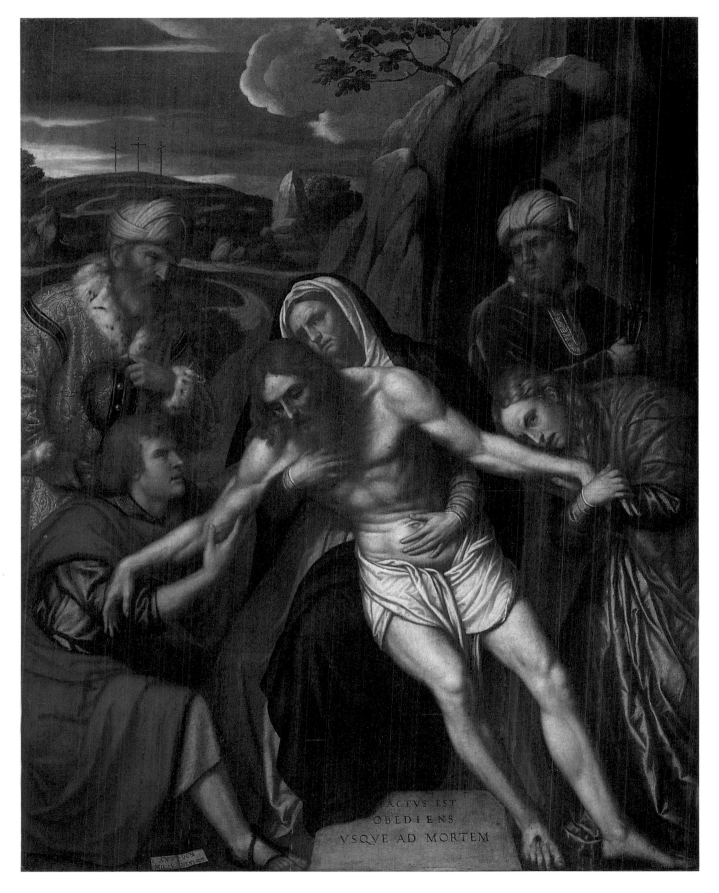

ACTVS EST
OBEDIENS
VSQVE AD MORTEM

B ut Mary [Magdalene] stood without at the
sepulchre weeping: and as she wept, she
stooped down, *and looked* into the sepulchre,
And seeth two angels in white sitting, the one at the
head, and the other at the feet, where the body of
Jesus had lain.

John 20: 11–12

THE DEAD CHRIST, WITH ANGELS
Edouard Manet

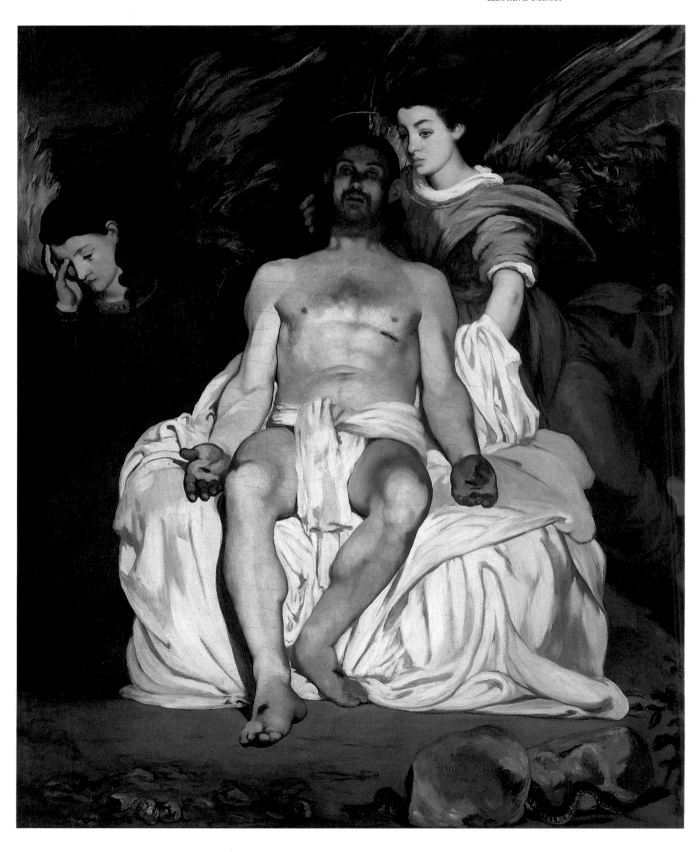

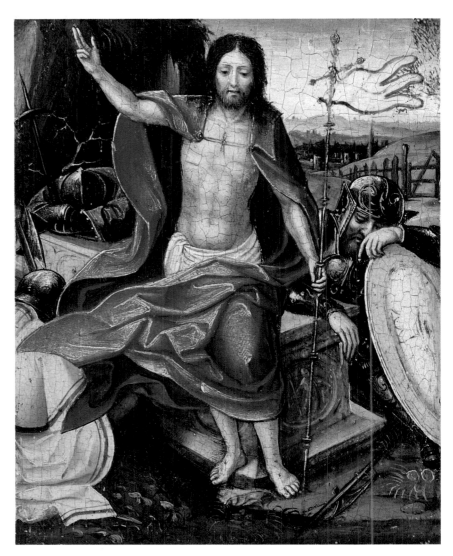

THE RESURRECTION
Unknown Flemish painter

A ND, behold, there was a great earthquake: for the angel of the Lord descended from heaven, and came and rolled back the stone from the door, and sat upon it.

MATTHEW 28: 2

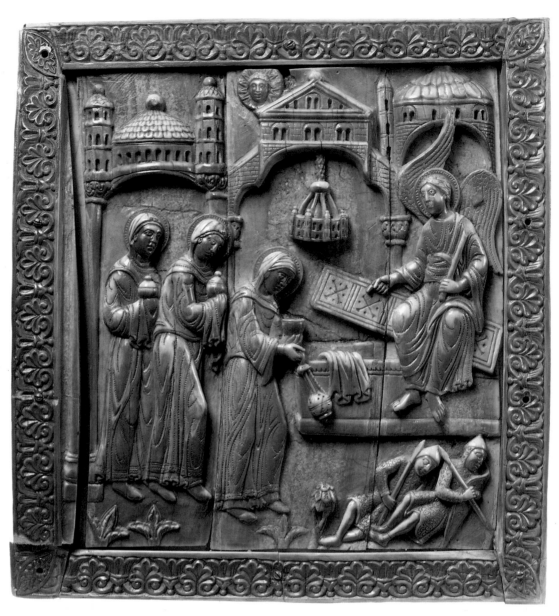

THE THREE MARYS AT THE SEPULCHER
Unknown German sculptor

A ND when the sabbath was past, Mary Magdalene, and Mary, the *mother* of James, and Salome, had bought sweet spices, that they might come and anoint him. And very early in the morning the first *day* of the week, they came unto the sepulchre at the rising of the sun. And they said among themselves, Who shall roll us away the stone from the door of the sepulchre? And when they looked, they saw that the stone was rolled away: for it was very great. And entering into the sepulchre, they saw a young man sitting on the right side, clothed in a long white garment; and they were affrighted. And he saith unto them, Be not affrighted: Ye seek Jesus of Nazareth, which was crucified: he is risen; he is not here; behold the place where they laid him. But go your way, tell his disciples and Peter that he goeth before you into Galilee: there shall ye see him, as he said unto you. And they went out quickly, and fled from the sepulchre; for they trembled and were amazed: neither said they any thing to any *man*; for they were afraid.

MARK 16: 1–8

BUT Thomas, one of the twelve, called Didymus, was
not with them when Jesus came. The other disciples
therefore said unto him, We have seen the Lord. But
he said unto them, Except I shall see in his hands the print of
the nails, and put my fingers into the print of the nails, and
thrust my hand into his side, I will not believe. And after eight
days again his disciples were within, and Thomas with them:
then came Jesus, the doors being shut, and stood in the midst,
and said, Peace *be* unto you. Then saith he to Thomas, Reach
hither thy finger, and behold my hands; and reach hither thy
hand, and thrust *it* into my side: and be not faithless, but
believing. And Thomas answered and said unto him, My Lord
and my God. Jesus saith unto him, Thomas, because thou hast
seen me, thou hast believed: blessed *are* they that have not seen,
and *yet* have believed.

JOHN 20: 24–29

DOUBTING THOMAS
Albrecht Dürer

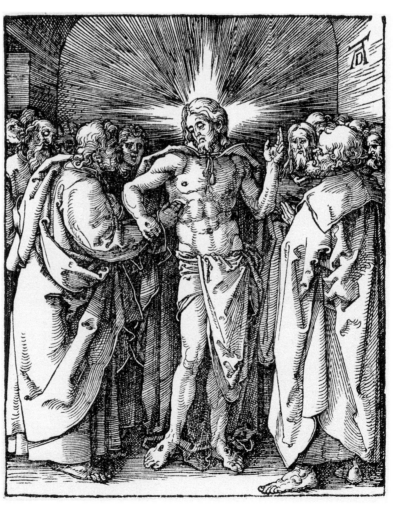

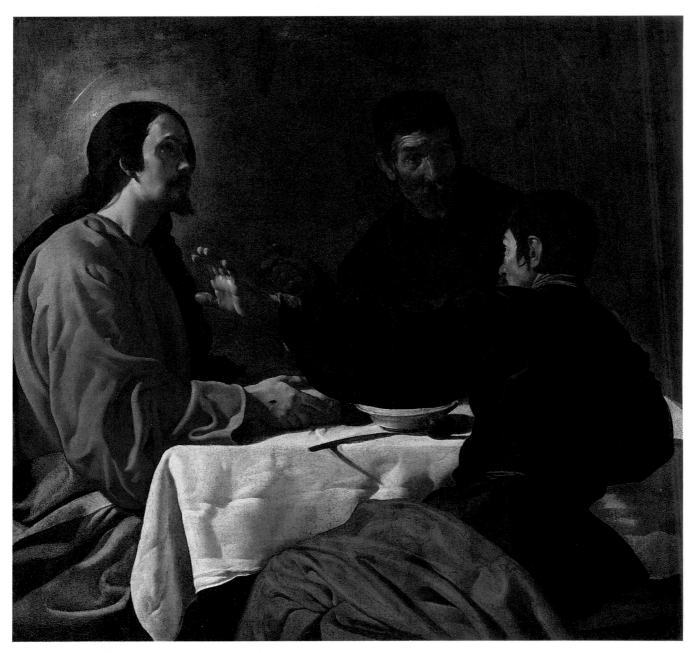

THE SUPPER AT EMMAUS
Velázquez

A ND, behold, two of them went that same day to a village called Emmaus, which was from Jerusalem *about* threescore furlongs. And they talked together of all these things which had happened. . . . And it came to pass, as he sat at meat with them, he took bread, and blessed *it*, and brake, and gave to them. And their eyes were opened, and they knew him; and he vanished out of their sight.

LUKE 24: 13–14, 30–31

AND it came to pass, while he blessed them, he was parted from them, and carried up into heaven. And they worshipped him, and returned to Jerusalem with great joy: And were continually in the temple, praising and blessing God. Amen.

LUKE 24: 51–53

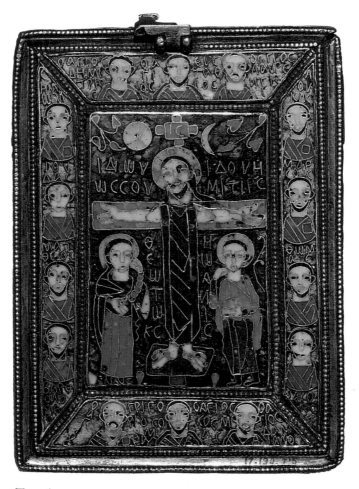

THE ASCENSION
Byzantine, 8th century

List of Illustrations

46 *Christ Presenting the Keys to Saint Peter*
German (Cologne), c. 1315–20
Pot-metal glass
Rogers Fund, 1929 (29.55.1, 2)

47 CAMILLO PROCACCINI
Italian, 1571–1629
The Transfiguration
Etching
Harris Brisbane Dick Fund, 1926 (26.70.4)

48–49 EL GRECO
Spanish, 1541–1614
The Miracle of Christ Healing the Blind
Oil on canvas
Gift of Mr. and Mrs. Charles Wrightsman, 1978
(1978.416)

50–51 REMBRANDT
Dutch, 1606–69
Christ Healing the Sick ("The Hundred Guilder
Print")
Etching
Bequest of Mrs. H. O. Havemeyer, 1929,
H. O. Havemeyer Collection (29.107.35)

52 DOMENICO FETTI
Italian (Roman), c. 1589–1623
The Good Samaritan
Oil on wood
Rogers Fund, 1930 (30.31)

53 LUCAS VAN LEYDEN
Dutch, 1494–1533
The Return of the Prodigal Son
Engraving
Harris Brisbane Dick Fund, 1926 (26.3.2)

54–55 PAOLO GEROLAMO PIOLA
Italian, 1666-1724
Christ in the House of Martha and Mary
Brush and brown wash, heightened with white,
on blue-green paper
Harry G. Sperling Fund, 1983 (1983.57)

56–57 PIETER BREUGHEL THE ELDER
Flemish, 1515/30–69
The Wise and Foolish Virgins
Engraving
Harris Brisbane Dick Fund, 1928 (28.4.27)

58 LUCAS CRANACH THE ELDER
German, 1472–1553
Christ Blessing the Children
Oil on wood
The Jack and Belle Linsky Collection, 1982
(1982.60.36)

59 LUCAS CRANACH THE ELDER
German, 1472–1553
Christ and the Adulteress
Oil on wood
The Jack and Belle Linsky Collection, 1982
(1982.60.35)

60 REMBRANDT
Dutch, 1606–69
The Raising of Lazarus
Etching
Gift of Henry Walters, 1917 (17.37.195)

61 MAESTRO GIORGIO ANDREOLI
Italian, Gubbio, active 1519–53
*Magdalen Anointing the Feet of Christ in the
House of Simon the Pharisee*
Majolica, dated 1528
Robert Lehman Collection, 1975 (1975.1.1103)

62 GEORGES DE LA TOUR
French, 1593–1652
The Penitent Magdalen
Oil on canvas
Gift of Mr. and Mrs. Charles Wrightsman, 1978
(1978.517)

63 REMBRANDT
Dutch, 1606–69
Christ Driving the Money Changers from the Temple
Etching
Gift of Felix M. Warburg and his family, 1941
(41.1.49)

64 UGOLINO DA NERIO
Italian, active 1317–27
The Last Supper
Tempera and gold on wood
Robert Lehman Collection, 1975 (1975.1.7)

66 ALBRECHT DÜRER
German, 1471–1528
Christ Washing Saint Peter's Feet
Woodcut
Gift of Junius S. Morgan, 1919 (19.73.179)

67 RAPHAEL
Italian (Umbrian), 1483–1520
The Agony in the Garden
Tempera and oil on wood
Funds from various donors, 1932 (32.130.1)

68–69 BARTOLOMMEO DI TOMASSO
Italian (Umbrian), active by 1425, died 1453/4
The Betrayal of Christ
Tempera on wood
Gwynne Andrews Fund, 1958 (58.87.1)

70 REMBRANDT
Dutch, 1606–69
Christ Before Pilate
Etching
Gift of Henry Walters, 1917 (17.37.79)

71 THE LIMBOURG BROTHERS
French, active 1406–8/9
The Delivery of Barabbas
Illuminated manuscript page from the *Belles
Heures* of Jean, Duke of Berry, folio 136
Tempera and gold on vellum
The Cloisters Collection, 1954 (54.1.1)

72 MATTIA PRETI
Italian (Neapolitan), 1613–99
Pilate Washing His Hands
Oil on canvas
Purchase, Gift of J. Pierpont Morgan and
Bequest of Helena W. Charlton, by exchange;
Gwynne Andrews, Marquand, and Rogers
Funds, Victor Wilbour Memorial Fund, The
Alfred N. Punnett Endowment Fund, and funds
from various donors, 1978 (1978.402)

73 *The Mocking of Christ/The Flagellation*
Leaf from a psalter
Tempera and gold leaf on vellum
English, c. 1250–70
Rogers Fund, 1922 (22.24.2)

74 *Ecce Homo*
German, 17th century
Silver
Ann and George Blumenthal Fund, 1973
(1973.286)

75 EL GRECO
Spanish, 1541–1614

Christ Carrying the Cross
Oil on canvas
Robert Lehman Collection, 1975 (1975.1.145)

76–77 MARTIN SCHÖNGAUER
German, 1430/45–91
The Road to Calvary
Wood engraving
Gift of Felix M. Warburg and his family, 1941
(41.1.26)

78–79 FRA ANGELICO (Guido di Pietro), 1387–1455
The Crucifixion
Tempera on wood, gold ground
Bequest of Benjamin Altman, 1913 (14.40.628)

80 JAN VAN EYCK
Flemish, active by 1422, died 1441
The Crucifixion
Tempera and oil on canvas, transferred from
wood
Fletcher Fund, 1933 (33.92a)

82–83 MANNER OF JEAN GOUJON
French, c. 1510–67
Descent from the Cross
Marble relief with traces of gilt
Fletcher Fund, 1929 (29.56)

84 PETRUS CHRISTUS
Flemish, active by 1444; died 1472/3
The Lamentation
Tempera and oil on wood
Gift of Henry G. Marquand, 1890.
Marquand Collection (91.26.12)

85 MORETTO DA BRESCIA
Italian, c. 1498–1554
The Entombment
Oil on canvas
John Stewart Kennedy Fund, 1912 (12.61)

86 EDOUARD MANET
French, 1832–83
The Dead Christ, with Angels
Oil on canvas
Bequest of Mrs. H. O. Havemeyer, 1929,
H. O. Havemeyer Collection (29.100.51)

87 UNKNOWN FLEMISH PAINTER (possibly
GOSWIJN VAN DER WEYDEN, Flemish, active by
1491, died after 1538)
The Fifteen Mysteries and the Virgin of the Rosary
(detail showing the Resurrection)
Tempera and oil on wood
Anonymous Bequest, 1984 (1987.290.3a–p)

88 *The Three Marys at the Sepulcher*
German (Cologne), c. 1135–40
Walrus ivory
Gift of George Blumenthal, 1941 (41.100.201)

89 ALBRECHT DÜRER
German, 1471–1528
Doubting Thomas
Woodcut
Gift of Junius S. Morgan, 1919 (19.73.203)

90 DIEGO RODRIGUEZ DE SILVA Y VELÁZQUEZ
Spanish, 1599–1660
The Supper at Emmaus
Oil on canvas
Bequest of Benjamin Altman, 1913 (14.40.631)

93 *Reliquary*
Byzantine, 8th century
Silver gilt, cloisonné enamel
Gift of J. Pierpont Morgan, 1917 (17.190.715)

Published by The Metropolitan Museum of Art, New York, and Charles Scribner's Sons, New York

Library of Congress Cataloging-in-Publication Data

Burn, Barbara
 The life of Christ : images from the Metropolitan
 Museum of Art / compiled by Barbara Burn.
 p. cm.
 ISBN 0-87099-549-9.—ISBN 0-684-19142-3 (Scribner)
 1. Jesus Christ—Art—Catalogs. 2. Art—New
York (N.Y.)—Catalogs. 3. Metropolitan Museum of
Art (New York, N.Y.)—Catalogs. I. Metropolitan
Museum of Art (New York, N.Y.) II. Title.
N8050.B88 1989 89-31796
704.9'4853'0940747471—dc20 CIP

Produced by The Metropolitan Museum of Art, New York

John P. O'Neill, *Editor in Chief*

Barbara Burn, *Project Supervisor*

Mary Ann Joulwan, *Designer*

Matthew Pimm, *Production*

Type set by U.S. Lithograph, typographers, New York
Printed and bound in Verona, Italy,
by Arnoldo Mondadori Editore, S.p.A.

All of the photographs in this book were made by the Photograph Studio of The Metropolitan Museum of Art.

On the jacket: *Head of Christ*, attributed to Rembrandt, Dutch, 1606–69. Bequest of Isaac D. Fletcher, 1917. Mr. and Mrs. Isaac D. Fletcher Collection. 17.120.222

On the title page and jacket verso: *Disk with the Nativity,* Italian (Tuscan), 1375–1400. Gift of J. Pierpont Morgan, 1917, 17.190.504

10 9 8 7 6 5 4 3 2 1